# GUSTAV KLIMT

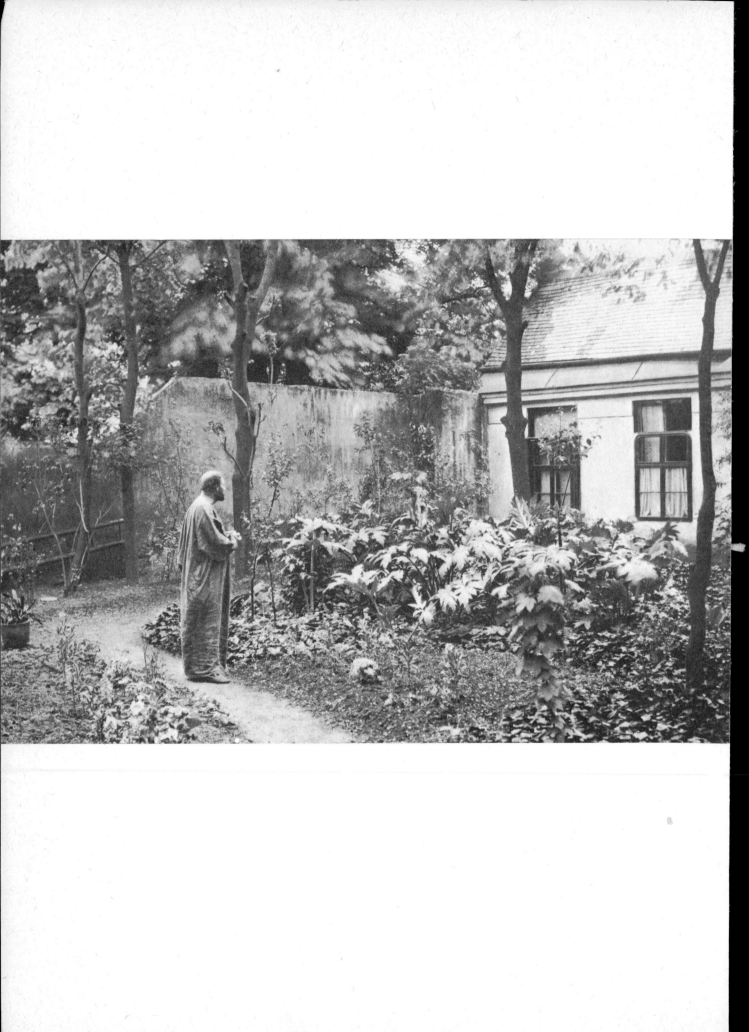

Alessandra Comini

George Braziller   New York

For Adriana and Eleanor

Published in 1975.
All rights reserved.
For information address the publisher:
George Braziller, Inc., One Park Avenue, New York,
New York 10016
The copyright for Klimt reproductions is exclusively
held by Verlag Galerie Welz Salzburg.
Printed by Mohndruck in West Germany
(Reproductions: G. Ludwig, Zell a. See).
Library of Congress Catalog Card Number: 75-10965
International Standard Book Number:
  0-8076-0805-x, cloth
  0-8076-0806-8, paper

## Acknowledgments

Innumerable thanks are due to Galerie Welz, Salzburg. In
addition I am grateful to the following private collectors
for their aid — immediate and generous — in providing re-
productions of their works: Dr. Otto Kallir, New York;
Viktor Fogarassy, Graz; and Erich Lederer, Geneva.

No scholar can deal with Klimt without incurring a
tremendous debt to two vast and authoritative works on
the artist: Johannes Dobai's oeuvre catalogue *Gustav
Klimt* of 1967 (with introduction by Fritz Novotny) and
Christian M. Nebehay's comprehensive *Klimt Dokumen-
tation* of 1969. The "D." numbers appearing in the text
and notes refer to the Dobai catalogue raisonne number-
ing.

Many thanks are due to Mike Firpo for his assistance
in the production/design of the book.

The readability of the text is due to the combined
alertness of Julianne J. deVere in New York and the
relentless editing of Megan Laird Comini in Dallas.

Frontispiece: Gustav Klimt in the
garden of his Josefstädterstrasse
studio, c. 1910. (Photograph, M.
Nähr, Vienna)

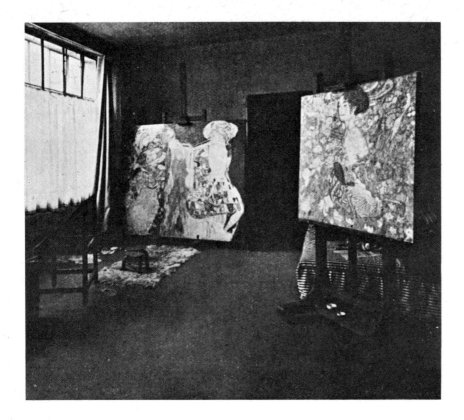

1. Photograph of Klimt's Hietzing studio at the time of his death, February 1918. (From E. Pirchan, *Gustav Klimt*, Vienna, 1956)

2. Klimt, detail from unfinished painting, *The Bride*, 1917–18.

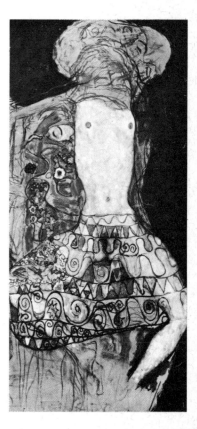

On a chilly thirteenth of January in the year 1918, in Vienna, burglars broke into a painter's studio while its owner was away and helped themselves to its contents. One thing they did not take, but at sight of which they must have paused in amazement, was a large, unfinished canvas on an easel next to the studio windows (Fig. 1). For here, even to the uninitiated, was an extraordinary revelation of what might be called a "dirty old-master" technique. In opposition to the floating knot of figures covering the left side of the canvas, the splayed-out nude body of young girl dominated the other half. Her face was averted in a profile turn to the right, and a mufflerlike wrap at the throat seemed to separate the head from its glimmering white torso, creating a startling effect of mutilation (Fig. 2 and Pl. 35). The knees were bent and the legs spread apart to expose a carefully detailed pubic area upon which the artist had leisurely begun to paint an overlay "dress" of suggestive and symbolic ornamental shapes.

The painting was called *The Bride*, and the absent owner of the studio was Gustav Klimt, who two days before had been felled by a stroke as he was dressing for his morning stroll to the Tivoli gardens for breakfast. Paralyzed on his right side, he was hospitalized and kept alive for a few weeks, but pneumonia set in and he died on the sixth day of February at the age of fifty-five. The unfinished painting, by the mere fact that it *was* unfinished, contained the clue to the erotic premise of Klimt's great allegories involving female figures. The unknown ransackers of the studio had, sheerly by accident, caught

the artist in the secret and revelatory act of flagrant voyeurism.

Such confirmation of the sexual implications of Klimt's decorative overlay surprised few of his contemporaries. As early as 1908 the outspoken Viennese architect and defender of a new, proto-Expressionist severity in art, Adolf Loos, had publicly accused Klimt and the artists of the Wiener Werkstätte—Vienna's arts-and-crafts center—of erotic pollution. In a speech intending to shock the complacent bourgeoisie, and published under the title *Ornament and Crime*, Loos discussed what he considered the erotic origin as well as the outdated "plague of ornament" besetting Austrian art:

> All art is erotic.
> The first ornament that was born, the cross, was of erotic origin. The first work of art, the first artistic act which the first artist scrawled on the wall to vent his exuberance was erotic. A horizontal line: the recumbent woman. A vertical line: the man penetrating her. . . .
> But the man of our own times who from an inner compulsion smears walls with erotic symbols is a criminal or a degenerate. . . .
> Just as ornament is no longer organically linked with our culture, so it is also no longer an expression of our culture.[1]

A fellow Viennese, Sigmund Freud, would have agreed with all of Loos's statements concerning the erotic element in art, but not with Loos's contention that ornament was no longer organically connected with or expressive of the present culture. Here Freud and Klimt both opposed Loos; for them the interpolation of a symbolic dream, or of a decorative overlay, was the *link* between the conscious and the unconscious life—an interpretable link in which manifest images pointed to the latent content of the psyche or world cycle.

It is not strange, in a neurotic, self-indulgent metropolis like Vienna—already titillated to the point of spontaneous combustion by the "erotic pollution" of Arthur Schnitzler's plays and Richard Strauss's operas—that both Klimt and Freud should have focused upon sex as the primary spectacle and motivating factor of life. What is surprising is that time and the sheer beauty of Klimt's sensuous facades have obscured the blunt urgency of that artist's close and unremitting fixation upon sexuality. History seems to have ascribed the full revelation as well as exploitation of sex in art to the Expressionist and Surrealist movements, interpreting the *Jugendstil* generation of Klimt and indeed the whole international Art nouveau movement as merely an erotic prelude. Nevertheless this prelude, orchestrated in a period of hypocritical Victorian repression, was of Wagnerian proportions—sensuous and insistent—a leitmotif that predicated what was to come.

What kind of person was Klimt? To look at, he could have been mistaken for a farmer, a carpenter, or a butcher (Figs. 3 and 56). He was heavyset with powerful shoulders and had strong dark features with an open gaze. His appearance gave no inkling of the exquisite delicacy of his work. Taciturn and uncommunicative by nature—in

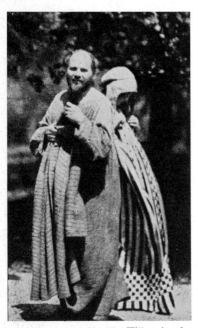

3. Klimt and Emilie Flöge in the garden of the Josefstädterstrasse studio, c. 1905–10. (Photograph, M. Nähr, Vienna)

4. Klimt's collection of Japanese color woodcuts and Chinese scrolls as installed in the foyer of his last studio in Hietzing, 1914–18. (Photograph, M. Nähr, Vienna)

fact bored by words—he let his paintings speak for him. As for his artistic sources and styles, how did the artist's personal predilections and convictions affect the content of his art and the reactions of his public? As late as 1899 when, to the enchantment of all Vienna, Klimt's *Schubert at the Piano* (Pl. 52) was installed in the music room of Nikolaus Dumba's villa on the Parkring, the painter and his work were considered quintessentially Austrian. Speaking for everybody, Hermann Bahr hailed the charming evocation of Schubert as the most beautiful picture ever painted by an Austrian, full of an inexpressible melancholy that was "wholly Austrian" in feeling.[2]

And yet, one year later, in May of 1900, after public exhibition of the painting *Philosophy* (Pl. 58)—the first of three pictures commissioned from Klimt by the Ministry of Education for the ceiling of the main hall of the University of Vienna—eighty-seven professors indignantly signed a petition denouncing Klimt's work as unacceptable. The bewildering iconography of nameless, naked humans floating in a cosmic cluster without direction and apparently without hope was contrary to the "School of Athens" hall-of-fame concept and seemed to pose a double threat of psychological spatial tension and ambiguous content. Klimt's search for a personal, rather than "Austrian," style in his three University pictures, *Medicine* (Pl. 19), *Philosophy*, and *Jurisprudence* (Pl. 59) left many of his previous admirers feeling excluded and betrayed. The criticism of Klimt's work which was to follow over the next few years until he withdrew from the public eye was, interestingly, based on ethical rather than artistic criteria. By pressing a private iconography upon a general public Klimt lost, in the opening year of the twentieth century, the universal acclaim which had previously pronounced him the greatest living Austrian painter.

In the same year, in nearby Munich, Klimt's formidable colleague and contemporary Franz Stuck (1863–1928) was being hailed as the city's "painter prince," as he continued to mesmerize public and critics alike with images of demonic universal principles such as "Sin," "Sphinx," "War," and "Lucifer." So close was much of the iconography of Klimt's and Stuck's Weltanschauung—in which the irrational ambiguities of the age were projected into powerful images (Figs. 24–26; Pls. 20, 21, 23, 25, and 31)—that a comparison of the two reigning painters and their respective domains is mandatory. The lifelong popular acceptance of Stuck—a painter now all but forgotten except as the teacher, briefly, of Kandinsky and Klee—no doubt reinforced the self-confidence emanating from his *Self-Portrait in His Studio with His Wife Mary* (Fig. 5). The hint of aristocratic aloofness —we see Stuck wearing his formal frock coat as he painted—was a genuine part of the Munich artist's aristocratic makeup. Both men received their artistic training at a Kunstgewerbeschule (applied arts school) rather than at an Academy. During the late 1880s both experienced commercial success and official recognition. Stuck won a prize of 60,000 marks and a gold medal at the Munich Glaspalast exhibi-

5. Franz Stuck, *Self-Portrait in His Studio with His Wife Mary*, 1902. Oil. Private collection, Munich.

6. The "Pompeian Wall" in the music room of the Stuck Villa, Munich, 1898. (Photograph from *Du*, July 1969)

tion of 1889 for his astonishing *Guardian of Paradise* (Fig. 25), and in 1888 Klimt received the golden service cross from Kaiser Franz Josef for his part in the ceiling and pediment decoration of the new Burgtheater. One critic now described Klimt as the "heir" of Hans Makart.

The careers of the two artists continued to parallel each other: in 1892 Stuck became one of the original members of the Munich Sezession; in 1897 Klimt joined in the founding of the Vienna Secession. At this time both painters represented the extreme avant-garde in art, but whereas Stuck was appointed professor of painting at the Munich Academy in 1895, Klimt, during the years 1893 to 1905, was three times blackballed for a similar post at the Vienna Academy, due to the drawn-out scandal (which rocked even the government) concerning the "unacceptability" of his three University paintings. Exasperated, Klimt proclaimed when interviewed by the art critic Bertha Zuckerkandl, whose sister-in-law he was to paint toward the end of his life (Pl. 16):

> Enough of censorship. I grasp at self-help. I want to get free.
> I want to get out of all these unrefreshing absurdities that hinder
> my work, and get back to freedom. I refuse all state help.
> I renounce everything.[3]

Klimt's self-image (Fig. 3) reveals a man who has indeed renounced the establishment in exchange for personal freedom. In contrast to the stiff formality of Stuck, handsomely silhouetted in his evening coat before his blank canvas, Klimt appears to be circling in a free-form dance, as he poses for his photographer friend Max Nähr not in his studio but in the luxurious garden he allowed to grow wild outside his studio door. In both instances a female companion shares the artist's body language. Stuck's wealthy American wife Mary, who financed the construction of her husband's renowned showpiece villa (completed 1898), is a statuesque figure, full of poise—a fittingly regal hostess for the painter prince's lavish home banquets. Emilie Flöge, the swirling partner in Klimt's dance step, is, in her wind-puffed dress and graceful pose, a harmonious counterpart of the freedom expressed by the painter's loose-fitting blue "monk's" tunic. Another kind of liberty also existed in the twenty-seven year relationship between Klimt and Emilie Flöge, the owner of a fashionable dressmaking shop. Although Klimt's younger brother Ernst (1864–1892) had married Emilie's sister Helene in 1891, Gustav and Emilie were never to formalize their union. For Klimt, this freedom to pursue the species female, not only as pictorial content but as the prey of daily encounter, was a natural and necessary way of life. Reluctant to provide a self-portrait in either words or painting, Klimt nonetheless once summed up the female-directed aesthetic of his life and art thus: "There exists no self-portrait by me. I am not interested in a specific personal appearance as a 'subject for a picture,' but rather am I interested in

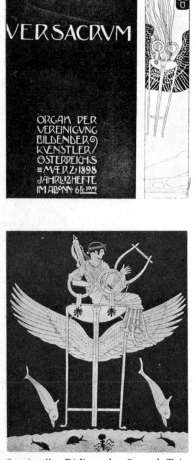

7. Klimt-designed cover for *Ver Sacrum*, 1898, Vol. 3, with the Delphic tripod far right. Compare with Fig. 8 and Pls. 1, 2.

8. *Apollo Riding the Sacred Tripod of Delphi*, detail from Attic red-figure vase, c. 490–475 B.C. (From H. Lukenbach, *Kunst und Geschichte,* Munich, 1913) Compare with Fig. 7 and Pls. 1, 2.

other individuals, above all women, and even more am I interested in other appearances."[4]

One of these "appearances" was Alma Schindler (soon to become Alma Mahler—Fig. 20). Perhaps Vienna's most beautiful femme fatale at the turn of the century, Alma vividly recalls Klimt and his pursuit of her when she was eighteen years old:

> He was . . . already famous at thirty-five, and strikingly good-looking. . . . He was tied down a hundredfold, to women, children, sisters, who turned into enemies for love of him. And yet he pursued me to Italy. . . . Wherever we stayed Klimt would show up looking for me. . . . In Venice, in the bustle of the Piazza San Marco, we finally saw each other again. The crowd concealed us and his hasty whispers of love, his vows to rid himself of everything and come for me, his commanding request to wait for him. . . . I was deaf to all pleas to visit his studio.[5]

If Klimt was not always successful in "commanding" women (according to Alma), he had nevertheless an engagingly frank attitude toward his Don Juanian appetites and once drew a swift caricature of himself as genitalia (Fig. 57)—a pithy self-portrait for a man of few words.

Continuing the comparison between Stuck and Klimt, a look at their studio furnishings is especially rewarding in determining the art tastes of these two great masters of eclecticism. Both artists lavished an arts-and-crafts-minded attention upon their ateliers. Stuck designed every feature of his nostalgically "classic" villa and lined the walls with sculpted altars to art and "Pompeian" frescoes (Fig. 6). Upon moving into what was to be his final studio in Hietzing in 1914, Klimt furnished his reception foyer with the elegant Wiener Werkstätte furniture of his friend the architect Josef Hoffmann and hung on the wall his much-prized collection of Japanese color woodcuts and Chinese scrolls (Fig. 4). While Stuck's creative emulation was limited, like that of Arnold Böcklin's, to the world of classical antiquity, the sources of Klimt's stylistic inspiration included, as had those of Makart, a far more catholic and esoteric range, extending from the ancient Orient through practically all periods of Western and non-Western art. In the contemporary area of the dance, just as Isadora Duncan's emphasis on Greece could be equated with Stuck's world, so Ruth St. Denis's employment of Egyptian and Indian motifs had a parallel in the orientalized decorative usage of Klimt (see especially the later portraits, Pls. 10–14). Both these extraordinary representatives of avant-garde dance performed in Vienna during Klimt's formative years: St. Denis's 1906 "Dance of the Sense of Touch" sent the city, and Hugo von Hofmannsthal in particular, into raptures. Sensuality was a Viennese speciality not limited to Klimt. However it was the cloying sexuality of Stuck's nymphs and satyrs that was dubbed "healthy" by writers like Hofmannsthal, who admired Stuck's "myth-making" ability, while the sense of Eros unabashedly pervading and generating Klimt's great cyclic statements (Pls. 19, 26, 32, 33, 35, 57,

9. Klimt, *Art of Ancient Greece II (The Girl from Tanagra)*, 1890–91 (D.56). Oil on stucco ground. Intercolumnar panel in the staircase of the Kunsthistorisches Museum, Vienna. Compare with Pl. 49.

and 59) struck not the acceptable note of titillation but an unwelcome vibration of apprehension and alarm.

Klimt's allegories and their disturbing implications were rejected in his own home city. Throughout his lifetime, his local fame and livelihood were based upon his portraits and landscapes—apparently harmless vehicles for the sumptuous talents of Austria's irrevocably sensuous painter prince.

10. Hans Makart, *Charlotte Wolter as Messalina*, 1876. Oil. Historisches Museum der Stadt Wien, Vienna. Compare with Pl. 3.

Gustav Klimt was born in Baumgarten, a country suburb of Vienna, on 14 July 1862, and was the oldest son among seven children. He and his two brothers Ernst (1864–1892) and Georg (1867–1931) were introduced to art through their father's profession of engraver in gold and silver. Georg also became a goldsmith, but both Gustav and Ernst showed special talent for drawing and painting, and were accepted in the recently established Kunstgewerbeschule. The brothers' first and most influential professor was Ferdinand Laufberger, who gave them and their fellow student Franz Matsch (1861–1942) superb training in a variety of media, including al fresco painting and mosaic. Laufberger recommended the trio for several architectural decoration commissions and the Klimt brothers earned extra money by drawing portraits from photographs—developing a marked ability to render sharp natural likenesses. The trio helped execute Hans Makart's conversion of the sixteenth-century woodcut series of the *Triumph of Maximilian I* into a spectacular pageant honoring Kaiser Franz Josef's silver wedding anniversary in 1879, and Gustav's early exposure to the world of Dürer was to provide an unusual iconographic model for future use (Figs. 37 and 39). In 1893, at the completion of their studies, Matsch and the Klimt brothers moved into a joint studio, working on commissions for the decoration of villas and theaters, at first out of town (Fiume and Bucharest, 1885; Carlsbad, 1886) and then in Vienna when the trio was hired to paint scenes from the history of the theater in the pediment and ceiling areas of the two staircases of the newly completed Burgtheater on Vienna's elegant Ringstrasse. For his part in the project, which included during the years 1886–1888 depicting historical views of "The Cart of Thespis," "Shakespeare's Globe Theater in London," "The Theater of Taormina," "The Altar of Dionysus," and "The Altar of Apollo," Klimt immersed himself in the study of original sources and spent hours examining the collection of antique vases in the imperial museum.[6] Just as Stuck did not hesitate to lift fauns and warriors off the classical vases in Munich's Glyptothek, so Klimt developed a marauding eye for handsome motifs which could serve the double cause of historicism and esoterica. He not only applied his new knowledge of forms of classical antiquity to the Burgtheater decorations, but also introduced classical artifacts such as the sacred Delphic tripod (Fig. 8) into the frames and borders of some of his first "photographic" portraits, such as those of the pianist *Joseph Pembauer* in 1890 (Pl. 1) and of the actor *Josef Lewinsky* of 1895 (Pl. 2). The combination of photo-

graphic realism and enigmatic frame "commentaries" produced an arresting effect which Klimt was later able to synthesize into powerful single images of simultaneous decorative and symbolic content (see for example *Adele Bloch-Bauer I* of 1907, Pl. 8). Klimt used the winged Delphic tripod motif once again in 1898 in his cover design for the third issue of the newly formed art magazine of the Secession, *Ver Sacrum* (Fig.7).

The most influential event in Klimt's early career as an architectural painter, and one that alerted him to the vast inventory of ornamental forms to be found in earlier art, was the 1890 commission which the Klimt trio (the brothers and Matsch) received to complete the decoration of the staircase of the great new Kunsthistorisches Museum, left uncompleted by the untimely death at the age of forty-four of Vienna's leading historical painter, Hans Makart (1840–1884). Makart's "heir" took on the new job with gusto. Even as a student he had admired Makart, and not always from a distance. Once, in their curiosity to see the master's giant works in progress, the trio had bribed Makart's servant to let them slip into the empty studio during the owner's daily siesta. It was not Makart's rococo style but his baroque *excess* that fascinated the young Klimt, inspiring him to similar efforts (Pl. 55). During the years in which he was to grapple with what Freud might have called a *horror vacuii* complex, Klimt drew on this Makartian overabundance to fill and flood his own environmental surrounds. The eight spandrels and three intercolumnar panels assigned to Klimt in the Museum were to span the history of art from Egypt of the Old Kingdom to Florence of the Cinquecento. It was back to the art books and local museum collections for Klimt and his colleagues, who prided themselves on historical authenticity.

Klimt, with his voracious visual appetite, had no trouble assimilating the forms and styles, and over the next two years he produced eleven elegant personifications, both male and female (including an Egyptian mummy, a goddess, an angel, and a child) set in archaeologically appropriate backgrounds. One of the female figures represented an aspect of Greek art—*The Girl from Tanagra* (Fig. 9). The Tanagra girl was actually a startlingly contemporary Viennese coquette, with heavy eyelids and an enigmatic, steady gaze, her figure arrested in the act of caressing a flower. Behind her is a large Attic black-figure amphora—a testimonial to Klimt's preference for Greek art and a precursor of a specific period quotation which the artist would include in the upper right half of his Pallas Athene of 1898 (Fig. 27 and Pl. 21). In the spandrels Athene appeared for the first time in Klimt's repertory, wearing a breastplate with a gorgon's head in the center, grasping a spear in the left hand and holding a small Nike figure in the right—all features which would reappear in Klimt's remarkable version of 1898. Notable for a certain cool aloofness as well as for their period authenticity, these handsome personifications became a mild sensation, for here certainly was the promise of a great and poetic proponent of familiar and trusted academic realism.

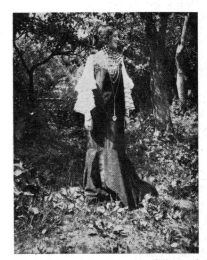

11. Photograph taken by Klimt of Emilie Flöge, c. 1905. (From *Deutsche Kunst und Dekoration*, XIX: I, 1906–07) Compare with Pl. 5.

12. Charles Rennie Mackintosh, detail of pilaster from the Board Room of the Glasgow School of Art, 1907–10. (From D. Bliss, *C. R. Mackintosh and The Glasgow School of Art*, Glasgow, 1961) Compare with Pl. 5.

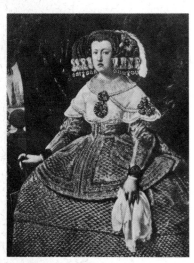

13. Diego Velázquez (formerly attributed to), *Portrait of Queen Mariana of Austria*, 1646. Oil. Kunsthistorisches Museum, Vienna.

14. Klimt, *Fritza Riedler*, 1906.

*The Girl from Tanagra* can surely qualify as Klimt's first portrayal of the femme fatale—a theme he would develop to frightening intensity in the *Judith I* and *Judith II* icons created after the turn of the century (Pls. 23 and 31). The charming fair-haired Tanagra girl, still nameless, appears soon again in the 1892 *In the Morning* (Pl. 49). No longer passing as a Greek evocation but an undeniable flesh-and-blood Viennese, she continues her sensuous association with flowers as she stands gazing melancholically at some blossoms in a mask-shaped vase on a high "Greek" table, of which one tall ornate leg can be seen. One flower, much taller than its neighbors, unfolds its petals around the luminous miniature face of a child—an interesting mixture of naturalism and symbolism (see also Pl. 50) which suggests the haunting formula of mysteriously sad females and mystic flowers employed so successfully by the Belgian painter Ferdinand Khnopff in his *I Lock My Door Upon Myself* of 1891. Klimt's stylization of the girl's fuzzy hair and prominent square jaw is also reminiscent of Khnopff's distinctive femme fatale type (Fig. 30). The motif in the large amphora in the background of *The Girl from Tanagra* appears as a background screen in *In the Morning*. Much later in the 1916 portrait of *Friedericke Maria Beer* (Pl. 13) an imposing "screen" behind the figure is not taken from one of Klimt's own large scrolls (Fig. 4) but is a magnification of a Korean vase in his collection. In all three works Klimt uses the psychological device of contrasting a ferociously active "painted" presence (the lively figures on the vase and screen) with the prominently passive aspect of the "real" subject.

Klimt's appreciation of Markart's painterly excess has been noted. A fine example of the younger painter's ability not only to update but to transform the highly popular Makart portrait formula may be observed in a comparison of Makart's 1876 portrait of the actress *Charlotte Wolter as Messalina* (Fig. 10) with one of Klimt's early portrayals of women, the 1898 *Sonja Knips* (Pl. 3). By retaining the asymmetrical figure placement and the foil of accompanying flower burst, and through the importance given to the handsome, two-dimensional body silhouette, Klimt has endowed the young socialite (she married a wealthy industrialist who installed the portrait in the dining room of their Josef Hoffmann-designed villa) with the same sensuous self-possession as that of Makart's Roman femme fatale. The Makartian "mood" of detachment—sometimes vacant, sometimes melancholy—was to become a hallmark of the manner in which Klimt's elegant women calmly eyed the world. Rejecting the close-up bust portrait (Pl. 50) for full-figure renditions, Klimt continued to elaborate on the Makart model of sensuous asymmetry, and the years 1901–02 found him experimenting with the individually applied, surface-filling, caressing brush strokes of Pointillism, as in the handsome portrait of *Marie Henneberg* (Pl. 53).[7]

As he lavished more attention on increasingly larger portrait canvases, Klimt's previous interest in providing additional decorative comment through the device of a wide border or frame (Pls. 1 and 2;

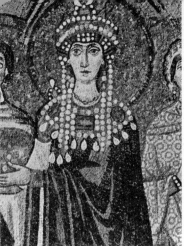

also Pl. 17, *Love*) diminished in favor of a heightened tension between three-dimensional figure and two-dimensional ground. The extension of environment to frame (a Pre-Raphaelite device much copied on the continent at this time) was carried out by Klimt's goldsmith brother, Georg, who provided the hammered copper frames for some of Klimt's early allegories (Pls. 21, 23). A brief flirtation with Whistler's white on white dissolving technique attempted to juxtapose the fixed reality of an individual persona with a complementary amorphic surround, as in the 1899 portrait of *Serena Lederer* (Pl. 4).[8]

A profound difference separates the Whistler-indebted *Serena Lederer* portrait of 1899 from Klimt's portrait of *Emilie Flöge* (Pl. 5) done three years later. Expressed in the simplest terms, external environment has here become interior definition. The diaphanous white surround of Serena Lederer is replaced by a specific body-filling swell of repeated decorative motifs. This is not the result of artistic distance or personal intimacy. Klimt knew both sitters well. Serena Lederer was a gifted amateur who admired and studied with Klimt and who encouraged her industrialist husband, August, to invest in what would one day be the largest private collection of Klimt works.[9] Emilie Flöge was, in the words of Serena's son Erich, "Klimt's *eternal* love"[10] and lifelong companion. Nevertheless the difference between the two portraits does not reflect the change in subject from patron to lover, but rather the birth of a novel concept—original with Klimt—of what could constitute portraiture.

In the years between the creation of the two portraits an extraordinary intellectual event had occurred in Vienna. Sigmund Freud's *The Interpretation of Dreams* (*Die Traumdeutung*) was published on 4 November 1899 in an edition of 600 copies.[11] Like so many of the voices raised to deliver urgent messages in that "isolation cell in which one was allowed to scream" (Karl Kraus's famous description of Vienna at the turn of the century), Freud's cry evoked only utter silence. The book was *ins Leere gesprochen* ("spoken into the void"— the publication title Adolf Loos gave his Vienna public lectures of 1897–1900) and largely ignored, except for a sneering review in the Vienna *Zeit* six weeks later—written by the former director of the Burgtheater, Burckhardt, who for some inexplicable reason qualified as an expert on such matters.[12] It is not likely that Klimt—no great devourer of books—ever read a word written by Freud; but it is almost certain that, in the culturally incestuous Vienna of coffeehouse gossip, Klimt was soon aware of the sexual fixation of the writings of Herr Doktor Freud well before Karl Kraus's devilish condemnation of psychoanalysis as "the disease of which it pretends to be the cure."[13]

Instinctively, and especially in the three University panels which so offended public taste, Klimt had been moving towards a cyclic conception of man, the natural world, and the cosmos in which everything was predicated on the single principle of fertility and regeneration. This was Nietzsche's lofty "eternal recurrence" theme as interpreted by Ernst Mach (1838–1916), popular lecturer and professor of

15. *Empress Theodora*, detail, 546–548. Mosaic. S. Vitale, Ravenna. Compare with Pl. 8.

16. Jan Van Eyck, detail of the Virgin Mary from the *Ghent Altarpiece*, completed 1432, St. Bavo, Ghent. Compare with Pl. 8.

17. Jan Toorop, *Verheugd Gouda*, 1897. Lithograph. Rijksprentenkabinet, Amsterdam. Compare with Pl. 8.

18. Friedericke Maria Beer in Wiener Werkstätte dress, c. 1916. (Photograph courtesy Mrs. F. Beer-Monti, Honolulu) Compare with Pl. 13.

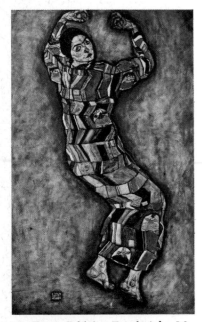

19. Egon Schiele, *Friedericke Maria Beer*, 1914 (K.192). Oil. Collection Mrs. F. Beer-Monti, Honolulu. Compare with Pl. 13.

physics at the University of Vienna, who saw the life experience as a tenuous membrane through which passed a series of stimuli and sensation, sensation and stimuli, like glistening pearls strung out in an endless continuum of space and time. In Klimt's laconic vernacular this meant an *interpenetration* between the fecundity of nature and that of man. This proto-Futurist interpretation of the world was for Klimt primarily a *visual* manifesto upon which could be built, if one cared to (and Klimt happily left this to his friends and critics), a philosophical superstructure.

The extremely personal route towards this Eros-centered environmental definition of man can quickly be appreciated by examining one of a dozen photographs which Klimt took of Emilie Flöge posing outdoors (Fig. 11), eight of which were published under Klimt's name in the respected art magazine *Deutsche Kunst und Dekoration*. With tremendous sensitivity and pleasure the artist-photographer juxtaposes the organic complexity of luxuriantly varied natural forms with the arbitrary and sophisticated shapes of the dressmaker's fashion design. Klimt's oil portrait of Emilie accomplishes the nature osmosis of which the ordinary camera is incapable: the garden is internalized—rhythmically absorbed into the figure of the woman and her billowing "halo" (perhaps reminiscent of the more sinister shadows of Félicien Rops and Edvard Munch). Klimt's *horror vacuii* has for once sucked the environment bare, concentrating on a central core of decoration. This ornamental trunk functions cumulatively and simultaneously as both ornate overlay and symbolic definition of the figure. And what is the symbolism? Like Freud's dream imagery, interpretation of the shapes depends on an almost oversimplified visual equation with traditional male and female symbols. Just as Loos dared to state that all art was erotic and could be reduced to the horizontal (woman) and the vertical (man), just as Freud confidently and blithely read tumescence into every erect object and penetrability into every orifice, so Klimt painted pollen and pistils, spermatozoa and ova interpenetrating both humans and nature. It is this basic message of inevitable, cycle-perpetuating Eros that streams forth from not only many of Klimt's portraits, but also from his undulating allegories and genetically overpopulated landscapes.

Unlike Freud and Loos (and the painters of the younger Expressionist generation—Richard Gerstl, Oskar Kokoschka, and Egon Schiele), who aimed directly at the psyche, Klimt manipulated the facade—the mysterious surface-membrane of those "other appearances" which he had admitted were his greatest interest. But the facade, as in Schnitzler's artfully contrived psychodramas, not only contained the message for Klimt, it *was* Klimt's message. It was the cumulative force of his decorative symbolism that impressed itself upon the beholder's unconscious. Reversing Freud's process, in which interpretation went from manifest dream imagery to latent content (the supposed presence of repressed libidinous desires), Klimt proceeded to translate the manifest Eros of his world view into latent

sexual symbolism—a shimmering facade of voluptuous ornament which could be seen as just that or as more, according to what was reflected in the eye of the beholder. Thus even such drastically straightforward sexuality as that presented in *The Kiss* of 1907–08 (Pl. 30) was able not only to pass the imperial censor but also to be accepted by the general public, so seductively distracting was the beauty of the gold and silver overlay in which erect rectangles and oculated spirals explicitly acted out the ultimate implication of the painting's title. The picture of Emilie Flöge is the first portrait in which Klimt expressed his new definition of portraiture—a definition in which anatomy becomes ornament and ornament becomes anatomy in a biological definition of the person portrayed (see also the allegorical pictures, Pls. 26, 30, 32, 33, 35, and 60; and the sheet of composition studies, Pl. 80). A handsome parallel and possible tribute to the sensuous possibilities of Klimt's two-dimensional kaleidoscopic filling of form can be observed in the eight plastically treated pilasters, of which no two have an identical inner fill (Fig. 12), designed by Charles Rennie Mackintosh for the Glasgow School of Art after his 1900 visit to Vienna to meet the Secessionist artists.[14]

Klimt's organic "flower" fills, with their symbolic appeal to the unconscious and their immediate impact of visible opulence, caused the artist to become greatly sought-after as portrait painter to Vienna's elite (if not to government officials). The art-loving nouveaux riches, which included many successful industrialists' families, clamored for the flattering elegance which a portrait by Klimt promised. In 1905 the artist completed a handsome wedding portrait of *Margaret Stonborough-Wittgenstein* (Pl. 6)—a composite of past experiments with the Whistler and Khnopff standing-figure formulas—and in addition provided, by means of a long white gown, a subtle, almost sgraffito flower-fill. A member of the remarkable family that produced the ascetic philosopher Ludwig Wittgenstein, Margaret was to place her embellished portrait by Klimt in a most ironic setting—the austere, white, multiple-cubed "house turned logic" designed for her by her brother Ludwig in 1927–28 in the best, most severe Loos "crime as ornament" spirit.[15]

An ingenious eclectic with an unquenchable thirst for evocative shapes that were also beautiful in themselves, Klimt did not hesitate to raid other art works. This he did with verve when he lifted the familiar fanned-out headdress of seventeenth-century female royalty from Velázquez examples in the Kunsthistorisches Museum (Fig. 13).[16] This headdress was adroitly transferred as a repetitive "wallpaper" motif (beginning on the far right of the canvas) to the 1906 portrait of the Berlin patron *Fritza Riedler* (Fig. 14 and Pls. 7 and 67), complementing the lady's upswept coiffure with an unforgettable (if recognizable) aggrandizement. The most extreme instance of Klimt's eclecticism, and the most formidable example of the novel metamorphosis which his creative assimilation could produce, is certainly the 1907 portrait of *Adele Bloch-Bauer I* (Pl. 8). Dubbed immediately—

20. Alma Schindler (-Mahler) posing with bearskin rug at beginning of her acquaintance with Klimt, c. 1898. (Photograph, private collection, New York)

21. Klimt, *Lady with Muff*, c. 1916–18 (D.207). Oil. Formerly Galerie Gustav Nebehay, Vienna, present whereabouts unknown.

22. Hellenistic terra-cotta comic mask, from Melos. British Museum. (From H. C. Baldry, *Ancient Greek Literature in its Living Concept*, London, 1968) Compare with Pls. 18, 56.

and correctly—"Byzantine" by Alma Mahler and others, this work was a confirmation of the lasting impression which the mosaic decorations of S. Vitale (Fig. 15) and other churches had made upon the artist during his 1903 trip to Ravenna. This "Byzantine" crowdedness and mosaiclike filling of surface had been distinguishing Klimt's landscapes for three years (see Pls. 39, 40, and 41) and would continue to enhance their glimmering jewellike intensity to the end of Klimt's career (Pls. 42–48; 64). In the Bloch-Bauer portrait the Byzantine invasion is so overwhelming that "impurities" such as the repeated Egyptian eye-triangle and the Mycenaean swirl (shown even in foreshortened view as part of the armchair definition on the right) escape notice at first glance. The taut contrast between the plasticity of the pale, rouged face and the two-dimensionality of the ornamental surround (employed in abridged form also in the portrait of *Fritza Riedler*) owes its pungency to a tension between realism and microscopic detail. This sort of tension had been present in Northern painting since the days of Jan Van Eyck, whose glittering Ghent Altarpiece figures (Fig. 16) indeed provide a formal precedent for Klimt's work, even to the inclusion of landscape greens alongside metallic sheens (see the single square of green just above Bloch-Bauer's head to the right and its repetition in the left foreground). The illusion of decapitation effected by the jeweled neck collar is a femme-fatale enhancing device that Klimt borrowed from his own earlier portraits (Pls. 5 and 50) and such allegorical works as his *Judith I* (see Fig. 59 and Pl. 23). The photographic realism of Klimt's organically isolated heads is also reminiscent of Jan Toorop's reliance on photography in his "portrait" lithograph celebrating the visit of Queen Regent Emma and Princess Wilhelmina to Gouda in 1897 (Fig. 17), a work in which the tension between surface flatness and three-dimensionality is stretched to the breaking point. The repetitive, stylized faces, tresses, ornaments, and flowers of Toorop—a favorite, along with Khnopff, of the Secession—were features carefully noted by Klimt. The flirtation of both Klimt and Toorop with photomontage effects parallels the new amusement park fad of being photographed with one's head poking out of an outlandish body or setting. (In 1913 even the generally morose Franz Kafka had himself photographed with three friends at the Prater "in" a cardboard airplane flying sedately over Vienna's giant Ferris wheel!)

Perhaps due to the influence of Emilie Flöge's Casa Piccola fashion shop activities, Klimt occasionally produced simpler portraits, such as *The Black Feather Hat* of 1910 (Pl. 9) and *Lady with Muff* of 1916–18 (Fig. 21), which were reassuringly and handsomely consonant with the latest fashions in women's wear and accessories, as seen in contemporary photographs showing real-life femme fatales (Fig. 20) coyly displaying the exaggerated hats or provocative fur muffs of the period.

The Byzantine victory in Klimt's portraiture was Pyrrhic. The tessera techniques which he had learned in the Kunstgewerbeschule

days proved more successful when translated into landscape painting than when allowed to overwhelm individual portrait sitters. The artist dipped into his reservoir again and came up with an inexhaustable supply of attractive objects and designs—this time from the Orient. Borrowing from his own prints (Fig. 4) and delving into his books on Japanese art (which included a collection of erotica), he began to lessen the density of his surface fill and with a much looser hand distributed here and there, in alternation with single flower blossoms, a supply of oriental birds, animals, and figures, as in the enchanting portrait (c. 1912) of the child *Mäda Primavesi* (Pl. 11). Klimt's enormous struggle to achieve a compromise between two- and three-dimensional elements is attested in a sheet of compositional studies for the portrait (Pl. 69). His ubiquitous awareness of gender and biology is also noteworthy in these studies, where the central vanishing point of the landscape orthogonals insistently coincides with the little girl's groin (an effect which is muted but present in the final painting, and is psychologically and compositionally germane to Klimt—see also Pl. 80, and Figs. 1 and 2).

The loosened "dotted oriental" fashion proved so pleasing that in 1912 Frau Bloch-Bauer requested a second portrait of herself in the "new" style. Klimt complied (Pls. 10 and 68). With this portrait he abandoned the Makart asymmetrical seated format for the centrally placed standing composition of his earlier works (*Serena Lederer, Emilie Flöge,* and *Margaret Stonborough-Wittgenstein*). Around 1914 Serena Lederer's striking, dark-haired daughter Elisabeth turned up for her wedding portrait, *Elisabeth Bachofen-Echt* (Pl. 12), and Klimt posed her within a pyramidal mantle of showering flowers set against a large screen peopled by his favorite oriental personalities (compare with Fig. 4), some of whom gaze with interest at the giant prisoner of ornament standing in front of their static world. From now on, with four notable exceptions due in three cases to the age of the sitter (portraits of a *Baby*, Pls. 15 and 72, of Serena Lederer's mother, *Charlotte Pulitzer,* Pls. 54 and 70, and of the mother of Emilie Flöge, D.191, not reproduced here), all of the women who came to Klimt for their portraits would be painted standing, usually in the center of the picture space, and facing the beholder (Pl. 14).[17] The other major exception to this rule was *Amalie Zuckerkandl* (Pl. 16), whose pyramid-shaped presentation was to remain unfinished, like that of the *Baby* (Pl. 15), because of Klimt's death.

"To be immortalized" had been the wish expressed by the timid *Friedericke Maria Beer* (Pl. 13 and Fig. 18) when she rode out to Klimt's Hietzing studio in November of 1915 to beg a portrait from Vienna's awesome painter prince. Her request was the result of an unusual circumstance. A wealthy and willful young presence on the periphery of the Viennese art world (she dressed exclusively in Wiener Werkstätte fabrics—Fig. 18), she had had her portrait painted two years before by the leading representative of the city's Expressionist artists, Egon Schiele (1890–1918). It was not Friedericke's admiration

26. Franz Stuck, *Pallas Athene*, c. 1897. Oil. (From O. J. Bierbaum, *Stuck*, Leipzig, 1899) Compare with Pl. 21.

27. Psiax, detail from *Heracles Wrestling with the Nemean Lion*, Attic black-figure amphora. (From J. Boardman, *Greek Art*, New York, 1964) Compare with Pl. 21.

28. Max Klinger, *Salome*, 1893. Marble. Museum der bildenden Künste, Leipzig. Compare with Fig. 32 and Pl. 23.

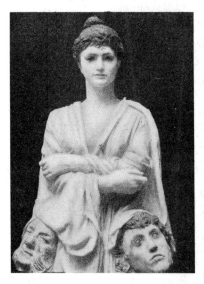

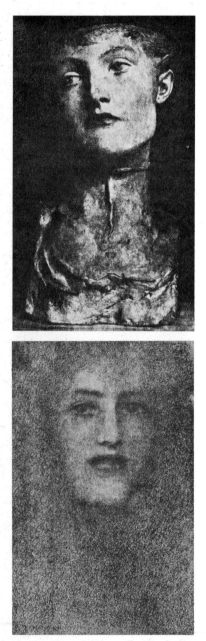

29. Ferdinand Khnopff, *Mask*, before 1898. Plaster. (From *Ver Sacrum*, I [1898], Vol. 12) Compare with Pl. 23.

30. Ferdinand Khnopff, *Red Lips*, before 1898. Colored drawing.

for the psyche-searing pinioning of her image in an angstful void, as portrayal in the new "pathological" Expressionist style guaranteed (Fig. 19), that had selected Schiele, but rather—and this by her own admission—her enthrallment by the troubled, wild good looks of the young bohemian painter.[18] Klimt now accepted her commission and decided on the imaginary background of a screen device, which he had first used in *In the Morning* (Pl. 49) and had recently elaborated in the *Elisabeth Bachofen-Echt* portrait (Pl. 12). His instinct for psychological and painterly tension quickened as he realized the marvelous natural contrast Friedericke's bland, symmetrical face made with the vivacious feints and parries of his oriental warriors. Upon completing the work he remarked to Friedericke, "Now people can no longer say that I paint only hysterical women."

Klimt created in this portrait perhaps his greatest statement of *decoration as content*—an Art nouveau thesis utterly opposed to the new Expressionist rejection of the facade. Nevertheless had it not been for Klimt's extraordinary overloading of the facade, with its double cargo of symbolic and ornamental content, the way to the psyche might never have been so fruitfully revealed to the younger generation of painters.

The incorporation into Klimt's allegories and landscapes of a meaning-saturated environment paralleled the development of the charged facade in Klimt's portraiture. A multiplicity of sources—some briefly experimented with and abandoned, others transformed and perpetrated—is also evident. At first, as in the description once given of Stuck, Klimt "acted baroque, but appeared Hellenic." From the early frank paraphrases of Makart's grandiose figure swirls in his earliest allegories, such as *Poet and Muse* (Pl. 55) of around 1884—humble precursor to the "human tower" knots of figures that would appear in the University panels (Pls. 19, 58, and 59) and that would culminate in the later allegories (Pls. 26, 32, 33, and 35)—he moved in 1895 to the friezelike scheme of *Music I* (Pl. 18), with its classical vocabulary of comic mask (compare Fig. 22), lute, and sphinx (the latter two very close to contemporary renditions by Stuck). Clearly his familiarity with past art styles had provided the artist with a cornucopia of classical quotations. Three years later, when he designed *Music II* (Pl. 56) as supraporta for the Dumba music salon—the same room in which his "Austrian" *Schubert at the Piano* (Pl. 52) was to be installed—he changed the formerly demure lyre-strummer into a more vivacious and definitely Viennese musician, and endowed her with the fuzzy fair hair and large square jaw of her sister cocotte, *The Girl from Tanagra* (Fig. 9). The classical mask of comedy appears as a Dionysian faun face in the second version and has been moved nearer the Khnopfflike sphinx.

In contrast to the two-dimensional accomplishment of the friezelike conception of *Music I*, the lure of a cosmic funnel of unknown depths was simultaneously beckoning the artist in another direction, as shown in a second allegory of the same year, *Love* (Pl. 17). This

first statement of the embrace theme, which Klimt would develop in the University panels, the Beethoven frieze (Fig. 40), and the Stoclet decorations (Pl. 29) into the mighty "Byzantine" climax of *The Kiss* (Pl. 30), seems, with its dramatic lighting, to come right off the stage of Klimt's own Burgtheater panel "Shakespeare's Globe Theater in London." Shown at a happier moment than the death scene depicted in the "Globe Theater" version, this Austrian Romeo and Juliet (again Klimt has modernized his woman into a contemporary Viennese type) close in for their ecstatic embrace under the group gaze of a transformed Cornaro Chapel audience—no aristocratic Roman family in Klimt's version, but instead dramatic examples of the inevitable progression of the species female from eager small child to dreamy young (Viennese-via-Khnopff) woman, to gaping crone (four variants of the latter are given) to the final monitory skull. What will happen to Romeo is not made explicit, for Klimt is only interested in the ages of woman (see this theme as taken up again in 1905, Pl. 26); only rarely after 1909 does a male enter the same canvas with Klimt's women (the two notable exceptions are *Adam and Eve*, Pl. 34, and *The Bride*, Pl. 35). The doomed-to-transiency embrace in *Love* takes place in a central dark oblong which peaks in Klimt's first baroque figure suspension since *Poet and Muse* and is framed on both sides by oblong gold borders decorated with fat Makartlike pink roses. All of the intriguing cast of characters in the top half of *Love* will be met with again in Klimt's further allegories.

A key work containing the germinal expression of what was to be one of the most original and compelling components of the University panels—the simultaneous presentation of multiple dimensional scales—is the 1896 pencil drawing *Sculpture* (Pl. 73).[19] Reminiscent of Klimt's nude image of Egyptian art at the Kunsthistorisches Museum, the new personification (an apple-holding "Eve") stands in front of a jumbled "Greek" altar loaded with sculpted objects such as the sphinx from *Music I* and crowned by a huge female head of the classic Athene type. Above this arrangement a circus maximus type of high bleacher wall extends, accommodating an attentive, if bizarre, audience of sculpted portrait busts in different media and from all art periods—an enthusiastic roundup in the name of Sculpture, even including a bust of Dante. While there are good reasons for the discrepancy in size of all these mutely staring heads, an irrational element in terms of both scale and theme makes its entrance on the extreme lower right of the picture—the "living" head at "Eve's" feet. Once again, as in *Music I* and *Love*, Klimt's introduction of a recognizably modern visage of a flesh-and-blood Viennese jostles all dimensions, in this case throwing doubt upon the previous norm of scale and reality, "Eve," forcing the beholder to ask whether she too is actually a statue.

In the meantime an unambiguously "real" sculpture was being hoisted into place in Vienna's Michaelerplatz (Fig. 23)—the Makartian baroque excess of which was to fire Klimt's imagination. Edmund

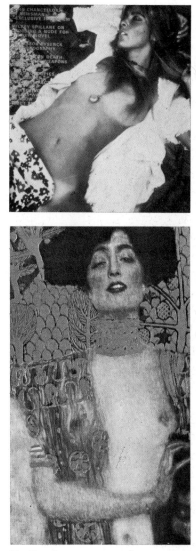

31. *Penthouse* magazine cover, April 1972.

32. Klimt, *Judith I*, 1901.

33. Detail from Assyrian palace relief of Sennacherib at Nineveh, 705–681 B.C. Compare with Pl. 23.

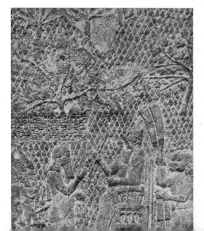

34. Gustav Mahler in 1897 at the age of 37. (Photograph, private collection)

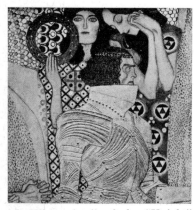

35. Klimt, detail of the "Knight" (supposedly Gustav Mahler) from the Beethoven frieze, 1902.

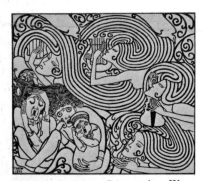

36. Jan Toorop, *Poster for Wagenaar's Cantata Schipbreuk*, 1895. Lithograph. Compare with Pl. 57.

Hellmer's marble fountain of 1897 depicting *Austria's Power on Land* was a swashbuckling ensemble of naked, cascading bodies high above which triumphed the figure of "Austria." The *sotto in su* view of "Austria" versus the floating human tower was incorporated by Klimt during 1897–98 into the basic design of his University picture *Medicine* (Pl. 19). Dozens of sketches (Pl. 76b) experimented with the posture and relationships of the figures in Klimt's column of humanity, which was to take up two-thirds of the canvas (Pl. 77), and special attention was given to the single nude figure occupying the otherwise empty left side of the canvas—the personification of "Austria" converted by Klimt into a floating female figure seen from the provocative "up from below" perspective (Pl. 76a).[20] The dramatis personae in *Love*, from babe to death's head (Pl. 77), make an impressive return in *Medicine*. In the final state, preserved now only in a photograph, Klimt introduced in the far upper right corner of the picture the pronouncedly pregnant nude woman who was to become a condensed statement of his Eros-generated cosmology in the drastic canvas *Hope I* (Pl. 24) and in the more "acceptable" version *Hope II* of 1907–08 (Pl. 60).

In his composition study (Pl. 75) for the University panel *Philosophy* (Pl. 58) Klimt again applied the coexistence of different figure-scales. This time the floating human column—composed of embracing couples, children, and Rodinlike despairing elderly figures—takes up a vertical strip on the far left side of the canvas and is opposed by a vast spangled area (Whistler's starry sky?) inhabited only by the huge blank-eyed female face we first saw as both sphinx and giant bust in *Sculpture*. And once again Klimt jolts the final logical cohesiveness of the ensemble by introducing, at the bottom left, the unmistakably modern face of a femme fatale mantled in her own flowing hair. The sphinx body of the large bust and the "philosophical" pose of the girl at the bottom of the compositional sketch were not carried over into the final state, which depended instead on a dramatic frontality for both staring visages.

The third University picture, *Jurisprudence*, was initially conceived of by Klimt as the single figure of a female Avenging Justice (Fig. 24) seen *sotto in su*. The image was unmistakably inspired by the painting that, a decade earlier, had made Franz Stuck famous overnight, the *Guardian of Paradise* of 1889 (Fig. 25). Again Klimt effects a gender transformation in his impressive paraphrase, but he retains that sense of contemporaneousness, in his square-jawed, bouffant-coiffured Justice, that had so impressed viewers of the Stuck picture in which many had read a self-portrait. In this first version of *Jurisprudence* another Klimtian character makes its first appearance—the tentacle-waving octopus in the lower portion of the picture. This bulgy-eyed apparition would soon appear just as a face, definitely male, voyeuristically accompanying the aquatic capers of Klimt's floating females in *Moving Water* of 1894 (Pl. 20) and would reappear in its most awesome (and now sexless) form in the final state of

*Jurisprudence* (Pl. 59). *Moving Water* took its cue from the sea-nymph frolics of Böcklin and Max Klinger, and its watery surround was to provide the symbol-polluted environment for two later versions of companionably close "swimming" females entitled *Water Serpents* (Pl. 25)—all images which, because of the multiple interpenetration invoked, served as models for the early Art-nouveau-obligated canvases of the Italian Futurist painter Carlo Carrà in, for example, his *Swimmers* of 1910 (Pittsburgh, Carnegie Institute).

The closest correspondence with a work by Stuck (Fig. 26)[21] in Klimt's allegories is the latter's imposing *Pallas Athene* of 1898 (Pl. 21). A much more original conception than the earlier Athene spandrel for the Kunsthistorisches Museum, this new rendition of the militant protectress of the Secession exhibits the coevality which had become the hallmark of Klimt's recent works. A large-jawed, red-haired implacable modern countenance gazes out from under a golden helmet. In her left hand Athene holds a spear while in her right she supports a miniature fair-haired version of herself as naked Nike. This is a predictably Viennese and specifically Klimtian refinement of the larger, draped, rigid historical Nike figure in Stuck's black-haired Pallas Athene version and is indeed a factor in the inescapable eloquence of Klimt's highly personal conception, pervaded as it is by a more persuasive god, Eros. Both paintings are enclosed within specially inscribed frames (Georg Klimt executed the metal frame from his brother's design). Here the resemblance ceases, for despite the similar pose and attributes, Klimt's figure is enriched by an "incised" background frieze, stylistically indebted to, on the left, late archaic vase painting and, on the right, Athenian black-figure work such as that by Psiax (Fig. 27). Klimt's little scene on the right shows Heracles wrestling with Antaeus—a favorite episode in classical vase painting, and one which the artist adopted from a local museum example or book illustration. The differentiation of flesh tone between male and female which the artist had noted in archaic Greek vase painting and which appears in the background decoration of *Pallas Athene* was a feature that would show up again in the late work *Adam and Eve* (Pl. 34).

Klimt himself was so intrigued by the charms of his tiny fair-haired Nike in *Pallas Athene* that the following year, playing Pygmalion, he blew her up to life size and called her *Nuda Veritas* (Pl. 22). Now a snake substitutes for the octopus as symbol of male presence and desire (there are perhaps more "disguised" Klimt self-portraits than are generally acknowledged) and winds across the ornate title to encircle the feet of the not at all squeamish red-haired incarnation of naked truth. A legend at the top of the panel proclaims in the words of Schiller the lofty message of *Nuda Veritas*: "You can not please all through your actions and your art—do it right for the few. To please many is bad." That *Nuda Veritas* did contain universal as well as personal appeal is verified in the reminiscence of Klimt's friend Bertha Zuckerkandl, who associated the creation of the paint-

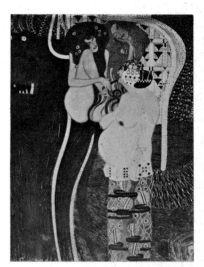

37. Klimt, detail of "Excess" from the Beethoven frieze, 1902.

38. Aubrey Beardsley, cover design for "The Forty Thieves," 1897.

39. Albrecht Dürer, detail of *Nemesis* ("Das grosse Glück"), 1501–02.

40. Klimt, detail of "Pure Joy" from the Beethoven frieze, 1902.

41. Charles Dana Gibson, *Design for Wall Paper Suitable for a Bachelor Apartment*, 1903. (From Dover reprint, *Gibson*)

*Opposite top and center*
42. Auguste Rodin, *She Who Was Once the Helmet-Maker's Beautiful Wife* ("The Old Courtesan"), 1888. Bronze. Compare with Pl. 59.

43. Mycenaean octopus motif on an amphora from Kakovatos, Triphylia, c. 1500–1425 B.C. National Museum, Athens. Compare with Pl. 59.

ing with the "fanatical cry for truth" excited by the reopening of the Dreyfus case in 1899.[22] Another art critic friend of Klimt's, Hermann Bahr (vigorous defender of the University panels), showed his appreciation of *Nuda Veritas* by purchasing it for installation in the study of his Joseph Olbrich-designed villa.[23] Before completion of the painting, Klimt published its basic design, with a different inscription at the top, in the third issue of *Ver Sacrum* (1898), along with a companion emblem representing "Envy" (*Der Neid*) (Pls. 74a and 74b) in which a gaunt old woman clutches the snake that ultimately preferred sharing the company of *Nuda Veritas* in the final oil.

The *Pallas Athene* of 1898 had been a symbol of the rational. Three years later Klimt's *Judith I* (Pl. 23) stunned and enthralled Viennese critics with its blatant decadence and terrifying invocation of the irrational. In spite of the artist's specially designed frame which identified the picture in large letters as "Judith and Holofernes," people simply could not or would not believe that Klimt had intended a portrayal of the pious Jewish widow and courageous heroine of the Apocrypha who, as Renaissance depictions had always shown, never actually delighted in her dreadful, heaven-directed mission of decapitating the plundering commander of the Assyrian army. Surely Klimt must have made a mistake; he must have meant Salome—that favorite fin-de-siècle femme fatale of Gustave Moreau, Oscar Wilde, Aubrey Beardsley, Franz Stuck, and Max Klinger (Fig. 28). Stubbornly, *Judith I* was listed throughout Klimt's lifetime in exhibition catalogues and magazine articles as "Salome," once even with the admonition that "Judith . . . would be better renamed Salome."[24] What Klimt was interested in carrying over from Salome precedents, such as the Klinger marble statue of 1893, was the arresting quality of living *presence*—of confrontation with a flesh-and-blood fatal woman. And fatal woman Klimt's *Judith I* certainly was: his palpable answer to Stuck's great plastic variations of the serpent-caressing femme fatale of *Sin*. We have seen the prominent-chinned female face before in Klimt, and the kinship with Khnopff types (Fig. 30) has been noted. But now a second Khnopff feature, as expressed in the Belgian artist's sculpture (Fig. 29), was observed and put to good use by Klimt. This was the powerful effect of decapitation suggested by the high neck collar (and reinforced in the Khnopff bust by a lopping-off of the top of the head). With trenchant yet extremely subtle means Klimt communicates the phenomenon of mutilation on three levels: the decapitated head of Holofernes, the jeweled-collar cleaving of Judith's head from her body, and finally the compositional bisecting of Judith's torso by means of drapery placement. The latter torso "amputation" proved so compelling a strategem that it was adopted *in toto* by Schiele for his tortured self-portraits and pictures of thrashing female bodies, and it is still a basis of modern erotic titillation (Fig. 31). Klimt's Judith has half-closed eyes and parted lips (Fig. 59). This is an expression of rapture that goes back to his dreamy woman floating above the embracing couple in *Love,* and

back to Bernini's *The Ecstasy of St. Theresa*. There is no mistaking the climax expressed in both versions. What makes Klimt's Judith so "evil" in her orgasm is the hideous conditions under which it is achieved—at the expense, in fact the death, of her partner. The coupling of death and sexuality would fascinate not only Klimt and Freud, but also all the European audiences who in 1909 went to shiver at the spectacle of Richard Strauss's bloodthirsty "Mycenaean Majesty" Clytemnestra (Fig. 58)—an uncanny stage counterpart (sung with extraordinary success in Vienna by Hermann Bahr's wife Anna Bahr-Mildenberg) to Klimt's sinister Judith.

Lest his unequivocal "Judith and Holofernes" frame identification become separated from its contents (as indeed it did in most reproductions of the work—Fig. 32),[25] Klimt painted, with an archaeological slyness unremarked by contemporary viewers, a specific biblical site reference right into his picture. The cone-shaped mountain symbols, the fig trees and grapevines behind Judith's head are all direct quotes from the Assyrian palace relief of Sennacherib (Fig. 33).[26] The painting (with its frame) was taken out of the country almost immediately by its appreciative first owner, Ferdinand Hodler, Klimt's great Swiss contemporary and creator of forceful allegories (Fig. 44) which paralleled many of the gestural and rhythmic qualities of the work of the Viennese artist.

Klimt had informed his version of the Judith and Holofernes story with a potent sensualism, transferring the thwarted lust of the historic Holofernes into the eroticism of a modern femme fatale. Whether or not he was aware of the fact that he had tampered with tradition in presenting Judith as a Salome, one thing is certain: in Klimt's book it was Judith—personal slayer of lust—who was the more spellbinding representative of Eros. Perhaps sparked by the stage appearance of the most terrifying femme fatale to date, Fanchette Verhunk (Fig. 47), in the 1907 Vienna premiere of Strauss's *Salome* (sets by the artist's friend Alfred Roller), Klimt returned to the devouring woman theme (Freud's "castrating" female) in 1909. But it was still Judith and not Salome that the artist, with the biological figure-fill symbolism of his latest portraits, chose to depict in the life-size icon *Judith II* (Pl. 31).

Somewhere between the rational world of Pallas Athene and the sensual domain of Judith there existed another region which Klimt visited in his allegorical work. "If I can not budge the gods, then I will move Acheron," was the line from Virgil's *Aeneid* with which Freud had prefaced his *Interpretation of Dreams*. Klimt too essayed a pictorial trip into the infernal regions (Pl. 57) when he elected to create a seven-part frieze in symbolic paraphrase of Beethoven's Ninth Symphony as part of an extravagant "frame" for the Secession's April 1902 exhibition of Max Klinger's Zeuslike *Monument to Beethoven*. For the exhibition, Gustav Mahler (Fig. 34)—controversial (partly due to Vienna's rabid anti-Semitism) director of the opera—reorchestrated the fourth movement of Beethoven's

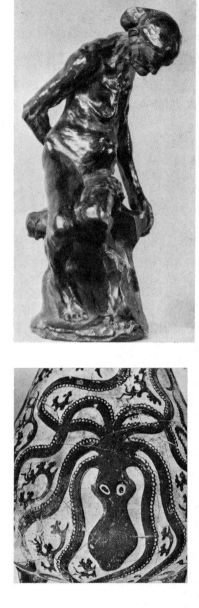

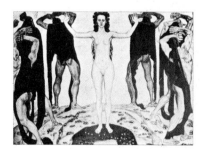

44. Ferdinand Hodler, *Truth II*, 1903. Oil. Kunsthaus, Zürich. Compare with Pl. 59.

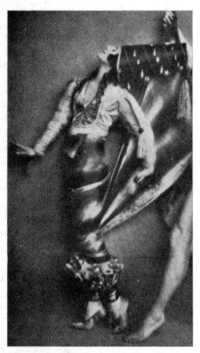

45. Anna Pavlova in the "Syrian Dance." (Photograph by Van Riel, 1917) Compare with Pl. 28.

46. Margaret MacDonald, "The Opera of the Sea," 1903. Decorative inlay in colored gesso. Waerndorfer music salon, Vienna. (From *Deutsche Kunst und Dekoration*, XV, 1904–05) Compare with Pls. 25, 29, and 30.

Ninth for wind and brass instruments and conducted it with the Vienna opera chorus in front of Klinger's statue on opening day. Klimt's accompanying frieze, executed in casein on a stucco base with semi-precious inlay, exemplified the turn-of-the-century concept of Beethoven's music as struggle and triumph. It began with a statement of mankind's longing for happiness, with the weak imploring the strong—a knight in shining armor (Fig. 35), identified by those in the know as representing Mahler himself[27]—to take up the struggle for happiness as a hero marching to victory. Facing the knight on the opposite wall was what would be his consolation—Poetry—but before he could reach this solace he had to pass through "the infernal regions" where dwelt the hostile powers of sin and vice. The monster Typhon (Pl. 57) is shown as a giant ape, next to the three Gorgons. The starkly linear and rhythmic style of this gruesome ensemble (it was here, rather than in *Judith I,* that the public spotted an "Assyrian" flatness) took its inspiration not only from Hodler but also from Toorop—possibly his "Shipwreck" poster of 1895 (Fig. 36), done, as was the Beethoven frieze, for illustration of a musical work. Next in Klimt's lineup came a trio of sins: debauchery, unchastity, and excess (Fig. 37). "Excess" was a blithe tribute to Beardsley (Fig. 38) and a not quite so blatant homage to Dürer (Fig. 39). The frieze climaxed, as did Schiller's words and Beethoven's music, with joy— as, leaving Acheron behind, man enters into a "kingdom not of this world," but a kingdom of pure joy. A choir of angels (Fig. 40) intones a line from Schiller's Ode, as "with a kiss for the whole world" pure love finds itself. Finally the Romeo of *Love* makes a long-awaited curtain call as the heroic nude who embraces "pure" love. The noble motivation of this kiss was not appreciated by the public or by most critics, who condemned the frieze as an allegory of venereal disease; painted pornography fit only for a Krafft-Ebing temple! Once again Klimt was attacked not for artistic reasons, but on behalf of morality. A year later, in America, Charles Dana Gibson was to bottle and cap the erotic vapors of such continental extravagances in an eau-de-cologne spray of femmes fatales as "wall paper suitable for a bachelor apartment" (Fig. 41).

Auguste Rodin visited the Beethoven exhibition in June of 1902 and complimented Klimt on his "tragic and magnificent" frieze.[28] The admiration was mutual, for the Austrian artist had already paid tribute to the Frenchman's *Gates of Hell* with the two despairing, head-clasping figures in the lower half of *Philosophy's* human tower (Pl. 58; see also *Three Ages of Woman,* Pl. 26). The following year Klimt made another Rodin figure (Fig. 42) the central motif of a new and monumental version of *Jurisprudence* (Pl. 59). The customary change of gender occurred: Rodin's shriveled hag became an emaciated old man, and the figure was shown *sotto in su*—a resigned prisoner of justice floating upwards in the prehensile grasp of a lilac-tinted octopus, a pulsating polyp whose artistic pedigree can be found in the tentacled motif of the Mycenaean vase painting (Fig.

43) admired by Klimt.[29] Two awesome spectacles greet the octopus's victim: around him are the three serpent-accompanied Eumenides— Tisiphone, Alecto, and Megaera; in the distance above another trio stands ready—Truth, revealing herself, Justice, garbed in red, and Law, holding her book. The drama's posterlike linearity may be indebted to Hodler (Fig. 44), but the message is Klimt's own: that vengeance stands in a much closer relationship to man than does the lofty concept of jurisprudence. Not exactly what the Vienna University law professors had in mind.

But even Klimt's first conception of *Jurisprudence* (Fig. 24) had been predicated on the idea of an Avenging Justice. While there seems to be no compensating connection between the happy, fulfilled aspect of the artist's private life with Emilie Flöge and the creation of so many femmes fatales and sensuous women (*Danae,* Pl. 27, *The Virgin,* Pl. 33, and *The Bride,* Pl. 35), the fact that Klimt's art had several times received official reprimands does seem to have provoked the very personal and pessimistic view of justice voiced in *Jurisprudence.* "Enough of censorship," the artist had declared. In 1905, eleven years after the fateful commission had been extended, he bought back from the government all three of the disputed University panels.

Creation of the dining-room wall mosaics for the Wiener-Werkstätte-designed villa of Adolphe Stoclet in Brussels during the years 1905–09 was a much more rewarding experience for Klimt. No ominous abstract needed to be pictorialized in this case. Instead, a Huysmanslike celebration of the senses was called for to accompany the formal dining of elegant society. The cartoons Klimt produced for the mosaic workers of the Wiener Werkstätte stemmed from his memory of the Ravenna church decorations. From the Byzantine spirals he raised a tree of life whose outstretched, curling branches encompassed two aspects of the greatest sensual experience: *Expectation* (Pls. 28 and 78) and *Fulfillment* (Pl. 29). *Fulfillment* was more than a clothed version of the "pure" kiss in the Beethoven frieze; it was Klimt's first chance to use the biological-ornament language of his latest portraits as visual definition of the merging of the two sexes. The emphasis on the exotic in the Stoclet decoration (M. Stoclet owned an exquisite collection of oriental art objects as well as a version of Khnopff's quixotic *I Lock My Door Upon Myself*) is seen in the "Egyptian" appearance of *Expectation* (referred to as "The Dancer" by a reviewer of 1912), whose frozen dance-step anticipates the impression of bas-relief silhouettes created by Anna Pavlova in her "Syrian Dance" of 1917 (Fig. 45).[30]

So successful was the statement of organic and decorative interpenetration in the Stoclet *Fulfillment* image that Klimt painted a life-size oil version in 1907–08 titled simply *The Kiss* (Pl. 30). The figures kneel on a flowery pedestal isolated in golden space, and the eventual culmination of mutuality of desire is beautifully enacted in the ornate intercourse of circular and vertical forms. The highly

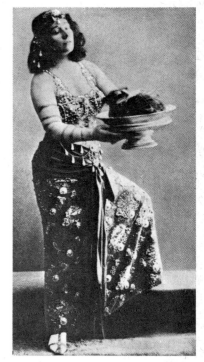

47. Fanchette Verhunk as Richard Strauss's *Salome* in the Vienna premiere of 1907. (From R. Tenschert, *Richard Strauss und Wien*, Vienna, 1949) Compare with Pl. 31.

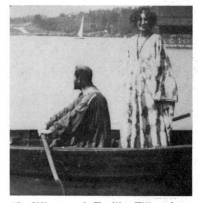

48. Klimt and Emilie Flöge in a rowboat on the Attersee, 1910. (Photograph, private collection, Oakland)

49. Ferdinand Georg Waldmüller, *The Schönberg*, 1834. Oil. Private collection, Vienna. Compare with Pl. 43.

50. Ferdinand Hodler, *Forest Stream*, 1904. Oil. Kunsthaus, Zürich.

51. Jean Dubuffet, *The Geologist*, 1950. Oil. Private collection, New York. Compare with Pls. 37, 42, and 43.

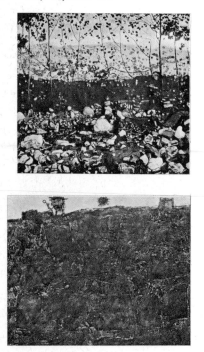

developed organic body-fill pervading and defining *The Kiss* may well have taken its original cue from the unusual flower-filled floating "kiss" precedent provided by a member of the Glasgow Four, Margaret MacDonald, whose decorative panel "The Opera of the Sea" (Fig. 46) was installed in 1903 in the music salon of one of the founders of the Wiener Werkstätte, Klimt's friend Fritz Waerndorfer.

With *The Kiss* Klimt parted company permanently with the robust forms of Rodin and declared his allegiance to the content-steeped, symbolic facade. His final allegories concentrated exclusively upon the Lucullan pleasure of painting overlays of sensual sign language on top of nakedly erotic images of themes and dreams (*Judith II*, Pl. 31, *The Virgin*, Pls. 33 and 79, and *The Bride*, Pl. 35; Figs. 1 and 2). Perhaps only the more sober allegory *Death and Life* (Pl. 32)—revised in 1915, in which the original gold background was overpainted with the stark blue of Alfred Roller's stage sky—gave any indication that Vienna's prince of Eros was aware of the world war thundering about him.

How did the symbol-saturated vocabulary of the portraits and the erotic syntax of the allegories find translation into Klimt's landscapes? For twenty years Klimt spent the summer months with Emilie Flöge and her family *in* nature, abandoning the stifling capital for the refreshing setting of small villages by Austria's sparkling Attersee (Fig. 48). An enthusiastic rower, Klimt often positioned his boat about thirty feet out from shore to obtain a private and uncluttered view of spots he wished to paint. Some of the first views, like *Island in the Attersee* (Pl. 37 and Fig. 54), are almost completely water scenes, and the loose brushstroke of Impressionism prevails. Common to both the early waterscapes and the first landscapes, such as *Farmhouse with Birch Trees* (Pl. 36), *After the Rain* (Pl. 61), and *Tall Poplars II* (Pl. 63), is the pronounced cutting of the canvas into unequal halves by either a very high or a very low horizon line. The two University panels *Medicine* and *Philosophy* depend on a similar asymmetrical dispersal of mass, and in fact, given a quarter turn, greatly resemble the top- or bottom-heavy landscapes painted during the same years. While such uneven distribution of space and volume is characteristic of the whole Art nouveau movement and of the oriental art from which so much of its spatial drama was obtained, there was a specific Austrian precedent which provided Klimt with a compositional trademark that so distinguishes even his earliest landscapes. This was the work of Ferdinand Georg Waldmüller (1793–1865). His landscapes, minutely-rendered but extensive in scope, such as *The Schönberg* (Fig. 49), frequently employed a narrow band of ground or sky as foil for dense motifs that could take up as much as six eighths of the picture area. This dramatic weighting of volume and the sheer beauty of Waldmüller's detailed surfaces opened Klimt's eyes to the pictorial tensions possible in the deliberate mixing of naturalism and schematism. The same antithesis of two-dimen-

sional ornament versus three-dimensional subject matter in Klimt's portraits and allegories charged the artist's increasingly diagrammatic views of exuberant, mosaic-studded nature, as in *Pear Tree* (Pl. 39), *Farm Garden with Sunflowers* (Pl. 40), *The Sunflower* (Pl. 41), *Poppy Field* (Pl. 42), and *Park* (Pl. 43). The horizon-swallowing space-negating mosaic *Park* comes very close to solving the *horror vacuii* suggested by Waldmüller, obsessive with Klimt, and still haunting later artists like Fritz Hundertwasser and Jean Dubuffet (Fig. 51).

Another pictorial precedent that contributed to the mesmerizing quality of Klimt's landscape densities was the rhythmic grouping of elemental verticals and horizontals in the "parallelism" practiced by Hodler in his landscapes, such as *Forest Stream* (Fig. 50). The multiple verticals of Klimt's forest scenes, as in *Beech Forest I* (Pl. 38), with its high "Waldmüller" horizon, is a basically corporeal response to the spiritual message of Hodler's eurhythmy and shares the rich carpetlike effect of repeated silhouettes and shapes.

Klimt composed his landscapes by using a small grid, through which he studied prospective scenes. A perfect square, usually 110x110 cm., became the preferred format for these schematized views of nature. The result of this squaring-off of vistas in nature (Fig. 55) was a stacked condensation of elements, glimmeringly beautiful in its tessera-filled articulation, as in *Church at Unterach on the Attersee* (Pl. 48). The sensuous pulsation of the artist's airless, unpeopled landscapes is particularly striking viewed up close (Fig. 53), and the palpable networks built up by Van Gogh's separated brush stroke (Fig. 52), which did so much to energize surface in modern painting, are indeed precursors to Klimt's nature mosaics. The difference is one of empathy versus harvest: nature for the desperate Van Gogh was a vibrant reassurance of existence within a cosmic void; for Klimt the plentitude of nature offered a cyclic variety of stimuli and sensations. Like a honeybee, the Austrian artist collected and stored in multifaceted display a precious hoard of sense impressions. Unaffected by time of day, light, or shade (Pls. 44–48), his impenetrable landscape facades sifted and solidified the phenomenon of fecundity. Schnitzler had stated that the natural state is chaos. Freud explored the symbolism of dreams and suggested a rational explanation for the irrational. Klimt faced the plurality of those "other appearances" and sought to paint the manifest-to-him content of a latent world force. Seizing upon the biological principle in nature, he studded his environments as he had his portraits with overlapping symbols of fertility and growth. Sometimes certain powerful forms correspond to the surface message of vitality, as in *The Black Bull* (Pl. 62) and *Tall Poplars II* (Pl. 63). At other times an early theme such as chickens in a garden (*After the Rain*, Pl. 61) will be reworked with magnified flower language and symbolic intensity, as in *Garden Path with Chickens* (Pl. 64). The anthropomorphic quality of Klimt's weeds and flowers, especially sunflowers (*The Sunflower*—Pl. 41), is undeniable and closely parallels the environment-absorbing portrait statements of pictures like *Emilie Flöge* (Pl. 5) and

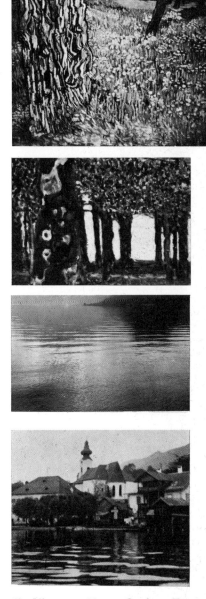

52. Vincent Van Gogh, *Tree Trunks and Flowering Grass*, 1890. Oil. Kröller-Müller Rijksmuseum, Otterlo.

53. Klimt, detail from *Park*, before 1910.

54. Island in the Attersee, Austria. (Photograph by the author) Compare with Pl. 37.

55. Church in Unterach on the Attersee, Austria. (Photograph by the author) Compare with Pl. 48.

*Adele Bloch-Bauer I* (Pl. 8). Just as he had summed up the Eros-centered conception of himself in the little self-portrait as genitalia (Fig. 57), so Klimt, caresser of all living things (Fig. 56), defined the omnipresent sensuality of nature in the following quatrain:

> *Die Wasserrose wächst am See*
> *Sie steht in Blüte*
> *Um einen schönen Mann ist weh*
> *Ihr am Gemüte.*

> The water-lily grows by the lake
> It is in bloom
> The yearning for a handsome man
> Is in her soul.[31]

So Klimt saw the world, others, and himself—all "in bloom" and all a part of the inexhaustible panorama of Eros. As observer of the greatest spectacle of all—Life—Klimt was indeed a *grand voyeur*.

56. Klimt and his cat in the garden of the Josefstädterstrasse studio, c. 1912–14.

57. Klimt, *Self-Portrait as Genitalia*, c. 1915. Drawing. Private collection, Geneva.

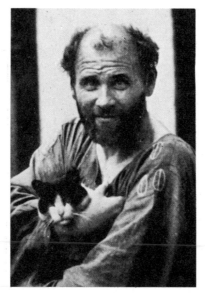 

# NOTES

1. Adolf Loos, *Sämtliche Schriften*, ed. Franz Glück. Vienna, 1962, I, p. 277 and p. 283. Author's translation.

2. Emil Pirchan, *Gustav Klimt*, Vienna, 1956, p. 22.

3. Bertha Zuckerkandl, *Zeitkunst: Wien 1901–1907*, Vienna, 1908, p. 165.

4. Klimt, typescript commentary for a non-existent "Self-Portrait," no date, Bibliothek der Stadt Wien, Vienna, as quoted in Nebehay, *Klimt Dokumentation*, p. 32. Author's translation.

5. Alma Mahler Werfel, *And the Bridge is Love*, New York, 1958, p. 12.

6. The drawing of motifs from Greek vases in the imperial collections was not Klimt's only museum copy work. As was traditional in all European capitals during this period, young artists spent a good deal of their time painting copies of the old masters from originals. In the summer of 1962, while leafing through an ancient permission-to-copy book at the Vienna Kunsthistorisches Museum in hopes of coming across just such an entry, I found under the date 28 April 1885, the signature of Gustav Klimt requesting permission to make an oil copy of Titian's *Isabella d'Este* (Entry reproduced in Nebehay, *Klimt Dokumentation*, p. 100).

7. Herr Henneberg, who commissioned Josef Hoffmann to build a villa on Vienna's exclusive Hohe Warte in 1901, was the owner of a sizeable Japanese print collection admired by Klimt. Two photographs showing the Klimt portrait in place over the fireplace of the Henneberg villa were published as early as 1903 in *Das Interieur*, Vol. 4, pp. 136–7.

8. See also Klimt's portrait of *Trude Steiner*, 1898 or 1899 (D. 104), the vivid face and dark hair of which were apparently painted posthumously from a photograph. Both white-on-white portraits may be fruitfully compared with their obvious forerunner, Whistler's *The White Girl* of 1862, in the National Gallery of Art, Washington, D.C. The influence of Ferdinand Khnopff's portraiture is also evident (See Khnopff's *Portrait of the Artist's Sister*, 1887, Bernard Thibaut de Maisières collection, Brussels).

9. Stored in what was thought to be a safe depot during World War II, almost all the works in this exquisite collection, which included many landscapes, *Music II*, and *Schubert at the Piano*, were destroyed by fire in the final days of the war.

10. Letter to me from Erich Lederer, 20 April 1975. I wish to acknowledge my great debt to Herr Lederer who, during my several visits to Geneva to study his important Klimt and Schiele collection, shared his extensive knowledge and vivid memories of Klimt and Schiele with me.

11. The publisher, Franz Deuticke, arbitrarily placed the date 1900 on the title page.

12. Ernest Jones, *The Life and Work of Sigmund Freud*, Garden City, 1963, p. 229. During the first six weeks after publication 123 copies of the book were bought; after that it took eight years before the remaining copies of the first edition of 600 were sold. A second edition was not published until ten years later.

13. Karl Kraus, *Die Fackel*, Nos. 376–7 (June 1913), p. 8. Kraus was attacking not Freud himself, but the extravagant claims made for psychoanalysis by Freud's disciples. Kraus and Freud—as clear-sighted critics of the sexual hypocrisy of Viennese society—held each other in mutual esteem, and the extent to which Kraus's searing articles on contemporary sexual practices served Freud has yet to be determined. See further my book *Egon Schiele's Portraits* (Berkeley, 1974) in which the instinctive grasp of the results of sexual repression by artists such as Klimt and Schiele is discussed as a phenomenon parallel to the theories and writings of Otto Weininger and Freud. In neither case do I believe that Klimt or Schiele ever actually read Freud, although they may well have looked at Weininger's *Geschlecht und Charakter*—notorious overnight—simply out of curiosity, due to the sensational suicide of the disturbed young author following the book's publication in 1903.

14. This interesting visual equation was originally suggested to me by Robert Brownlee in a student report delivered at Southern Methodist University in the summer of 1971. For an analysis of Mackintosh's impact on Vienna, see the essay by Eduard F. Sekler, "Mackintosh and Vienna," in J. M. Richard and Nikolaus Pevsner (eds.), *The Anti-Rationalists*, Wisbech, 1973, pp. 136–142.

15. For an anecdote concerning the ludicrous discrepancy between Ludwig's unkempt appearance and the aristocratic elegance of his sister in Klimt's portrait, see the family reminiscences of Hermine Wittgenstein (Ludwig's oldest sister—an amateur painter and good friend of Klimt) as published in Bernhard Leitner, *The Architecture of Ludwig Wittgenstein—a Documentation*, Halifax, 1973, p. 22.

16. The astute art critic Ludwig Hevesi was the first to remark on Klimt's use here of a Velázquez device, relating it to the painting of the Infanta Maria Teresa; see Hevesi, *Altkunst–Neukunst*, Vienna, 1909, p. 318.

17. In the unfinished *Portrait of a Lady*, although the head faces the beholder, the profile turn of the body is a rare exception to the completely frontal portrait format now adopted by Klimt. Dobai does not identify the sitter, but Erich Lederer recalls that she is Maria Munk, daughter of a Viennese industrialist and fiancée of the writer Hans Heinz Ewers (letter to me of 20 April 1975).

18. Friedericke Maria Beer, in conversations and letters to me over the past eleven years. For a full account of the Friedericke Maria Beer portraits by Schiele and by Klimt see my *Egon Schiele's Portraits*, pp. 127–132.

19. One of a series of drawings made by Klimt for eleven design contributions "in Renaissance style" for Martin Gerlach's two-part publication *Allegorien und Embleme*, Vienna, 1882 ff; issued in installments, with a *Neue Folge*, from spring 1896, in which Klimt's *Sculpture* was plate 66.

20. Pl. 76a may well be Klimt's first notation of the floating female figure for *Medicine*; the pencil sketch was jotted down on a piece of letter paper. Klimt had already used a mild form of *sotto in su* perspective for the nude female in his "Altar of Dionysus" lunette for the Burgtheater (D.40), 1886-88.

21. The Pallas Athene of Stuck's oil painting was reproduced as a poster in May of 1897 for the seventh International Kunstausstellung (June–October) in the Munich Glaspalast.

22. Berta Szeps( -Zuckerkandl, *My Life and History*, New York, 1939, pp. 182–3.

23. Already photographed in place and reproduced in *Das Interieur*, 1901, Vol. 2, p. 30 and Vol. 10, p. 163.

24. *Die Kunst*, 1901, Vol. 3, p. 540. See also the "Salome"-identified color reproduction facing the article on Klimt by Hugo Haberfeld in *Die Kunst*, 1912, Vol. 25, opp. p. 173. The Salome theme's interest for contemporary art historians was demonstrated by an article authored by E. W. Bredt, "Die Bilder der Salome," in *Die Kunst*, 1903, Vol. 7, pp. 249–54, with reproductions of the works of Beardsley and Klinger, among others.

25. Reproduced without its frame as in Fig. 32 of this book in the Haberfeld article cited above, note 24.

26. I am indebted to Professor Robert Alexander of the University of Iowa for his interest and alertness in pointing out to me this previously unnoticed Klimt borrowing. I am also grateful to his colleague, Professor Charles Cuttler, for sharpening my awareness of the important Judith-versus-Salome concept of this painting.

27. Alma Mahler, *Gustav Mahler, Memories and Letters*, New York, 1969 (revised ed.), p. 348.

28. Szeps( -Zuckerkandl), *My Life and History*, p. 181.

29. Instances of Mycenaean-inspired motifs in Klimt were first noted by Jaroslav Leshko, "Klimt, Kokoschka und die Mykenischen Funde," *Mitteilungen der Österreichischen Galerie*, 1969, XIII; Vol. 57, pp. 16–40.

30. Pavlova's early collaborator, Diaghilev, was in fact one of the signers of M. Stoclet's guestbook.

31. Poem dated 10 July 1917, in Klimt's flourishing script; illustrated in the Albertina Museum *Klimt Gedächtnisausstellung* catalogue (October–December), Vienna, 1962, opp. Pl. 1.

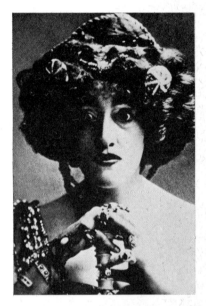

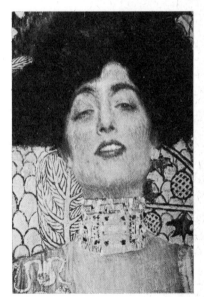

58. Anna Bahr-Mildenburg as Clytemnestra in Richard Strauss's *Electra*, Vienna, 1909. (From *Du*, April 1963)

59. Klimt, detail from *Judith I*, 1901.

# LIST OF PLATES

42 POPPY FIELD, 1907, D.149. Oil on canvas, 110x110 cm. Österreichische Galerie, Vienna.

43 PARK, before 1910, D.165. Oil on canvas, 110x110 cm. The Museum of Modern Art New York; Gertrude A. Mellon Foundation.

44 SCHLOSS KAMMER ON THE ATTERSEE, III, 1910, D.171. Oil on canvas, 110x110 cm. Österreichische Galerie, Vienna.

45 AVENUE IN SCHLOSS KAMMER PARK, 1912, D.181. Oil on canvas, 110x110 cm. Österreichische Galerie, Vienna.

46 MALCESINE ON LAKE GARDA, 1913, D.186. Oil on canvas, 110x110 cm. Formerly collection August Lederer, Vienna, destroyed by fire 1945.

47 SCHONBRUNN PARK, 1916, D.194. Oil on canvas, 110x110 cm. Private collection, Graz.

48 CHURCH AT UNTERACH ON THE ATTERSEE, 1916, D.198. Oil on canvas, 110x110 cm. Private collection, Graz.

49 IN THE MORNING, 1892, D.61. Watercolor on paper, 38.5x14 cm. Formerly collection Lobmeyr, Vienna, present whereabouts unknown.

50 PORTRAIT OF A LADY (Frau Heymann?), c.1894, D.65. Oil on wood, 39x23 cm. Historisches Museum der Stadt Wien, Vienna.

51 CHILDREN WITH FLOWERS, 1896, D.76. Oil on canvas (?), dimensions unknown. Whereabouts unknown.

52 SCHUBERT AT THE PIANO, 1899, D.101. Oil on canvas, 150x200 cm. Formerly collection August Lederer, destroyed by fire 1945.

53 MARIE HENNEBERG, 1901–02, D.123. Oil on canvas, 140x140. Formerly collection Henneberg, Vienna, now at City Gallery Moritzberg, Halle.

54 CHARLOTTE PULITZER, 1915, D.190. Oil on canvas, 98x98 cm. Formerly collection August Lederer, whereabouts unknown since 1945.

55 POET AND MUSE, c.1884, D.19 A. Oil on cardboard, 31.5x30 cm. Collection Dr. F. Ephraim, Lugano.

56 MUSIC II, 1898, D.89. Oil on canvas, 150x200 cm. Formerly collection August Lederer, destroyed by fire 1945.

57 BEETHOVEN FRIEZE, 1902, D.127. Casein colors on stucco with semi-precious inlay divided into seven compartments on three walls, 220x2,400 cm. Österreichische Galerie, Vienna.

58 PHILOSOPHY, final state, 1899–1907, D.105. Oil on canvas, 430x300 cm. Formerly Österreichische Galerie, Vienna, destroyed by fire 1945.

59 JURISPRUDENCE, 1903–07, D.128. Oil on canvas, 430x300 cm. Formerly Österreichische Galerie, Vienna, destroyed by fire 1945.

60 HOPE II, 1907–08, D.155. Oil on canvas, 110x110 cm. Private collection, Vienna.

61 AFTER THE RAIN (GARDEN WITH CHICKENS IN ST. AGATHA), 1899, D.107. Oil on canvas, 80x40 cm. Österreichische Galerie, Vienna, on loan to Neue Galerie der Stadt Linz Wolfgang-Gurlitt-Museum, Linz.

62 THE BLACK BULL, 1900–01, D.115. Oil on canvas. Private collection, Vienna.

63 TALL POPLARS II (APPROACHING THUNDERSTORM), 1903, D.135. Oil on canvas, 100x100 cm. Private collection, Vienna.

64 GARDEN PATH WITH CHICKENS, 1917, D.215. Oil on canvas, 110x110 cm. Formerly collection Erich Lederer, Geneva, destroyed by fire 1945.

65 STUDY FOR PORTRAIT OF SONJA KNIPS, 1898. Pencil and black crayon, 45.2x 32.4 cm. Historisches Museum der Stadt Wien, Vienna.

66 STUDY FOR PORTRAIT OF ADELE BLOCHBAUER I, c.1900. Black crayon, 45x31 cm. Albertina, Vienna.

67 STUDY FOR PORTRAIT OF FRITZA RIEDLER, 1906. Black crayon, 45.2x31.6 cm. Historisches Museum der Stadt Wien, Vienna.

68 STUDY FOR PORTRAIT OF ADELE BLOCHBAUER II, 1912. Pencil, 56.7x37.2 cm. Albertina, Vienna.

69 TEN COMPOSITION STUDIES FOR MÄDA PRIMAVESI, c.1912. From E. Pirchan, *Gustav Klimt.*

70 STUDY FOR PORTRAIT OF CHARLOTTE PULITZER, c.1915. Pencil. Collection Viktor Fogarassy, Graz.

71 STUDY FOR PORTRAIT OF A WOMAN, 1914–16. Pencil, 56.9x37.5 cm. Albertina, Vienna.

72 BABY STUDIES, 1917–18. Pencil. Collection Viktor Fogarassy, Graz.

73 SCULPTURE, 1896. Black crayon and pencil with white chalk and gold, 41.8x 31.3 cm. Historisches Museum der Stadt Wien, Vienna.

74a, *Drawings for* TWO EMBLEMS FOR VER
74b SACRUM: NUDA VERITAS AND DER NEID, 1898. Courtesy, Galerie Welz, Salzburg.

75 COMPOSITION STUDY FOR PHILOSOPHY, 1898–99. Black crayon and pencil, 89.6x63.2 cm. Historisches Museum der Stadt Wien, Vienna.

76a FLOATING FEMALE STUDY FOR MEDICINE, c.1898. Private collection, Dallas.

76b STUDY OF EMBRACING FIGURES FOR MEDICINE, 1898–1900. Pencil, 43x29 cm. Albertina, Vienna.

77 COMPOSITION STUDY FOR MEDICINE, 1899–1900. Black crayon and pencil, 86x62 cm. Albertina, Vienna.

78 STUDY FOR EXPECTATION, c.1906. Pencil, 55.8x36.9 cm. Collection Dr. Hermann Goja.

79 STUDY FOR THE VIRGIN, 1913. Pencil, 56.6x37 cm. Drawing Collection of the Federal College of Technology, Zurich.

80 SIX POSTER DESIGNS FOR OTTO WAGNER EXHIBITION, c.1914–16. Pencil. Collection Erich Lederer, Geneva.

# The Plates

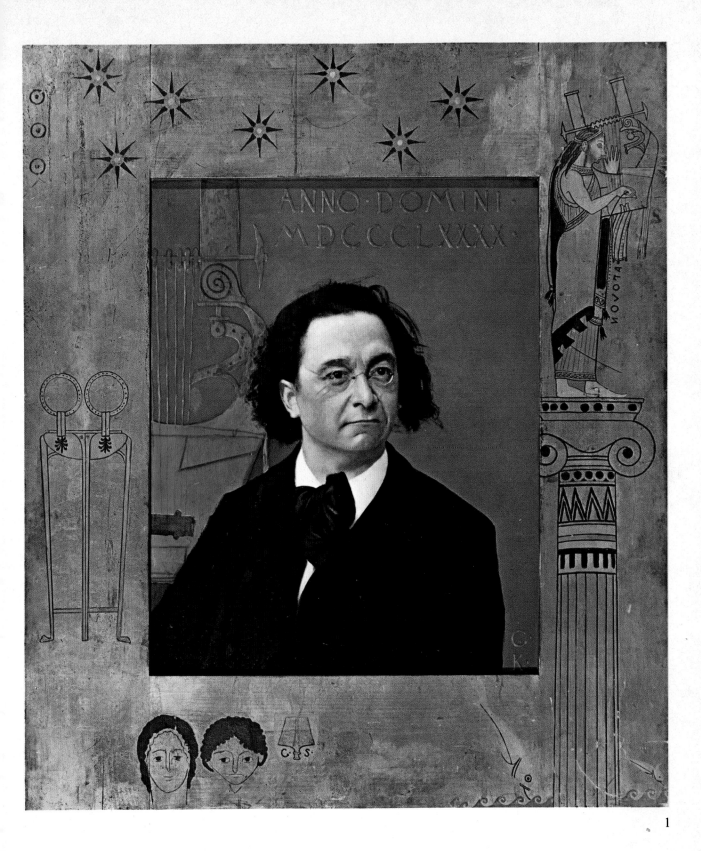

ANNO·DOMINI·
MDCCCLXXXX·

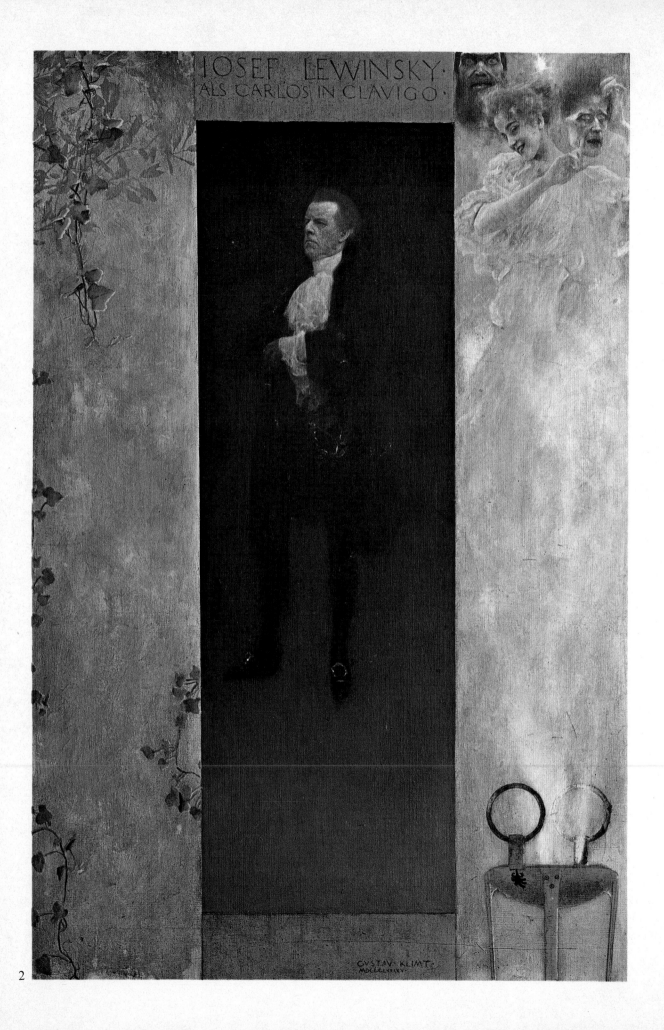

2

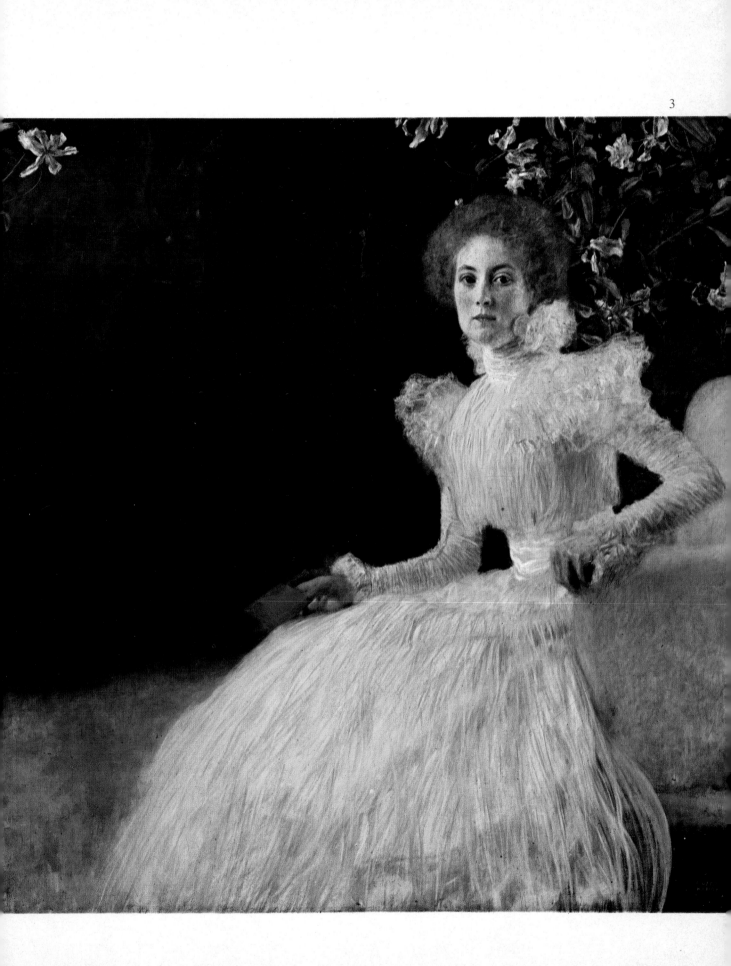

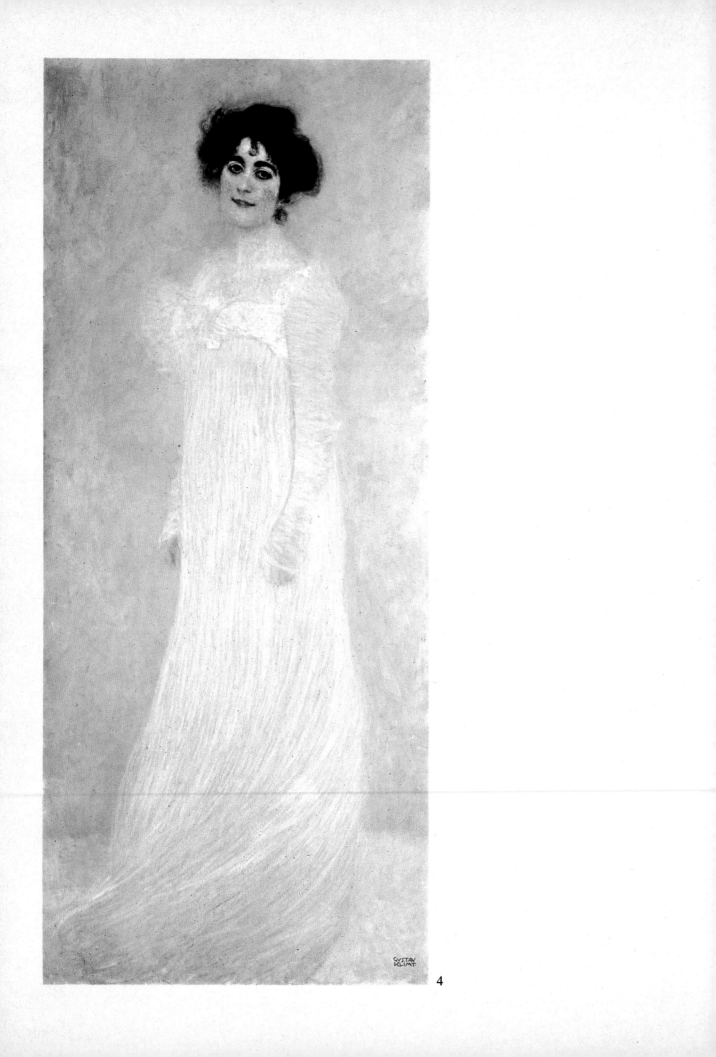

4

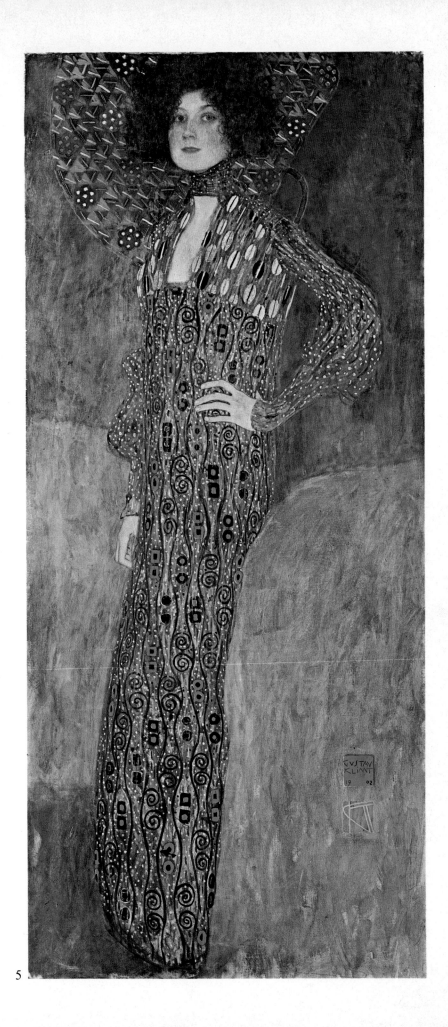

5

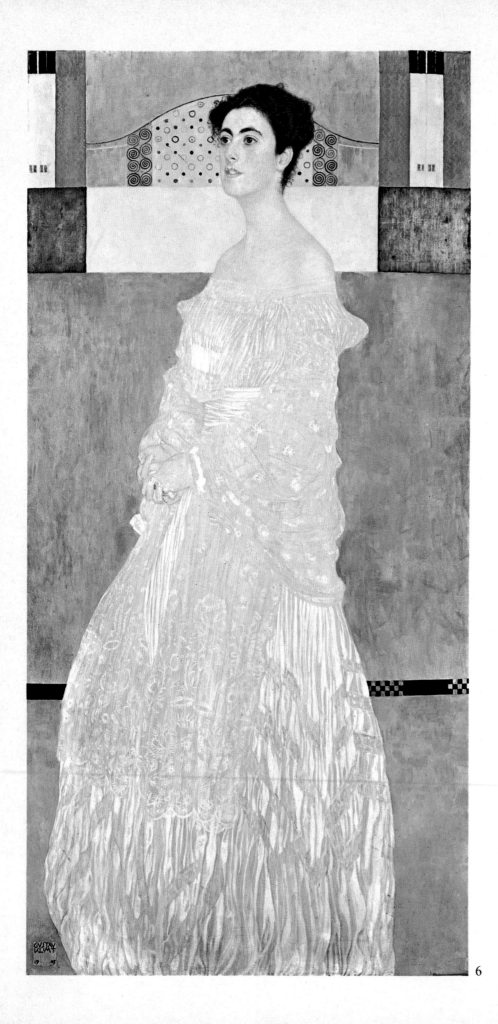

6

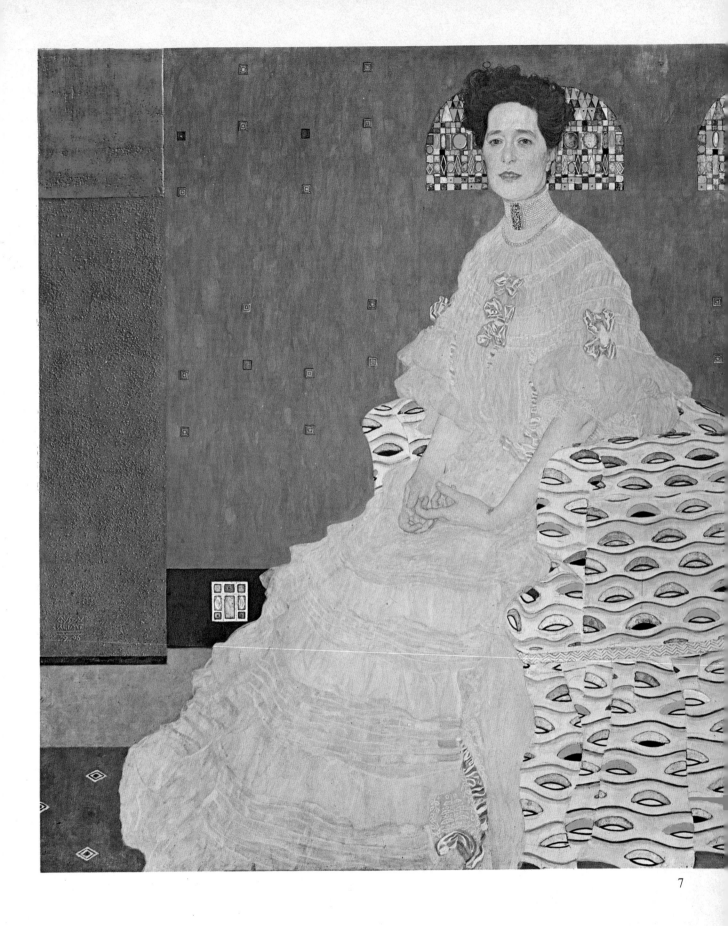

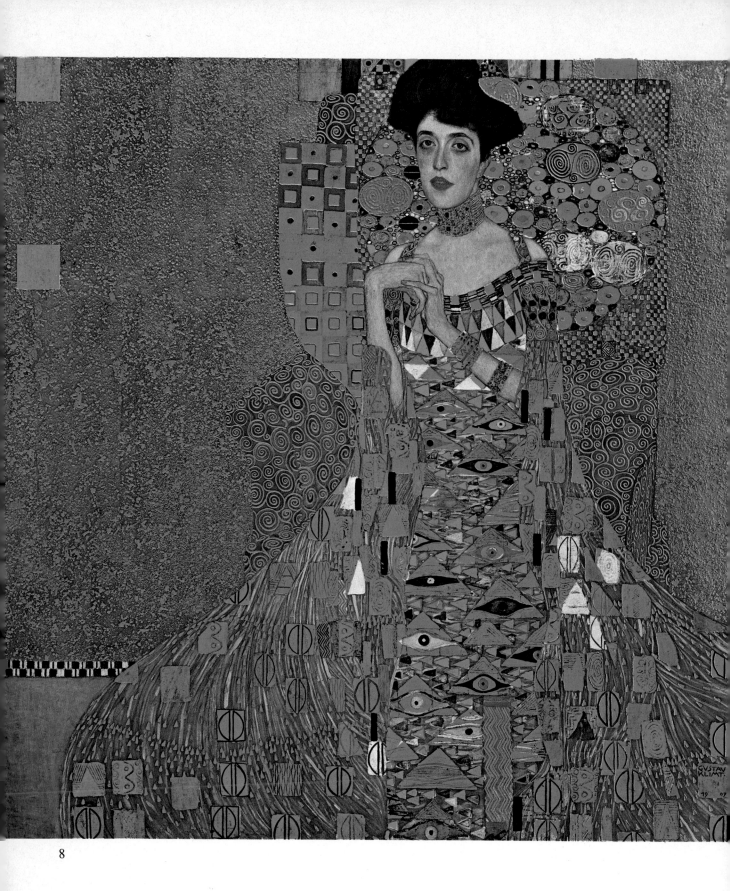

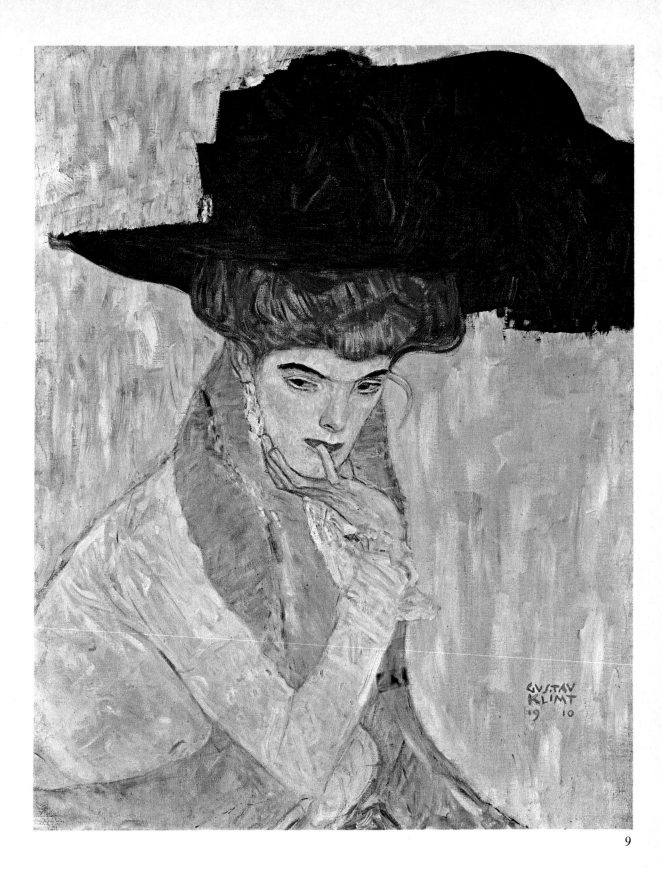

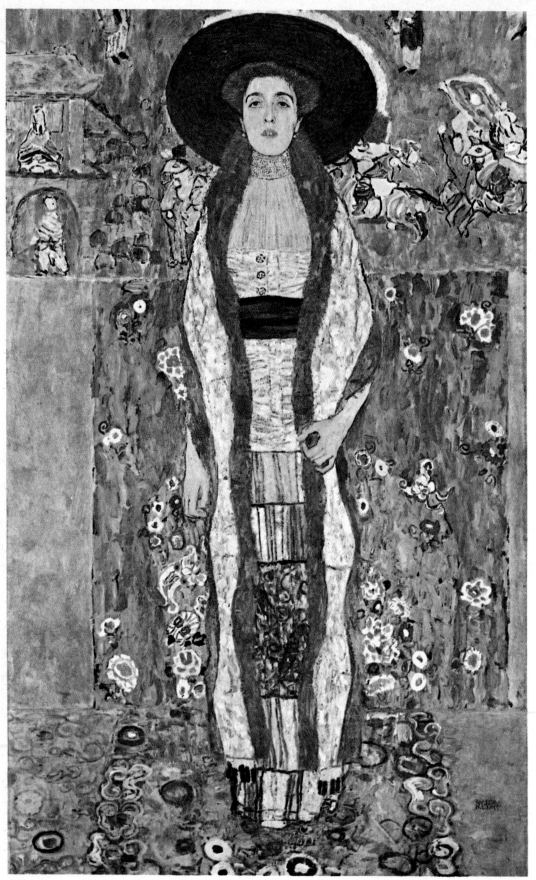

10

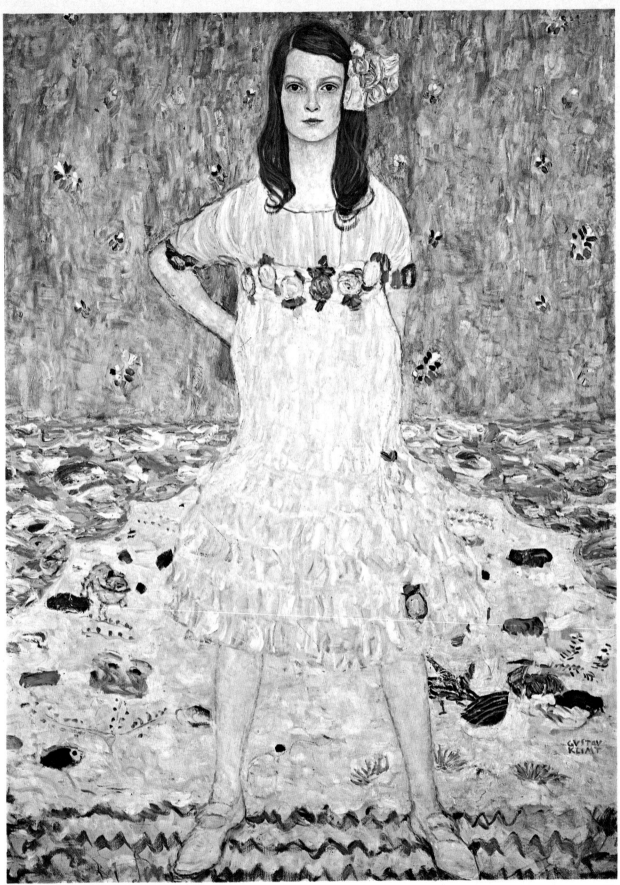

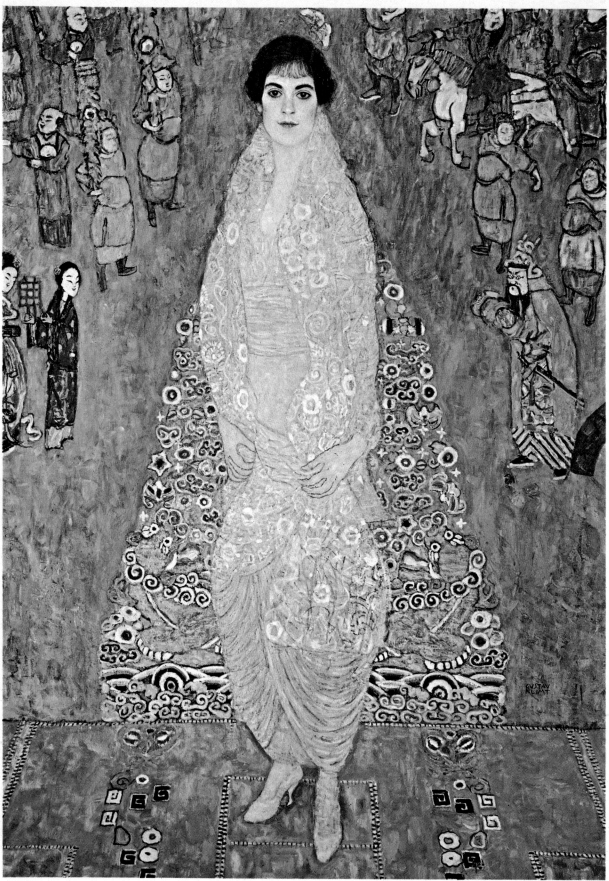

12

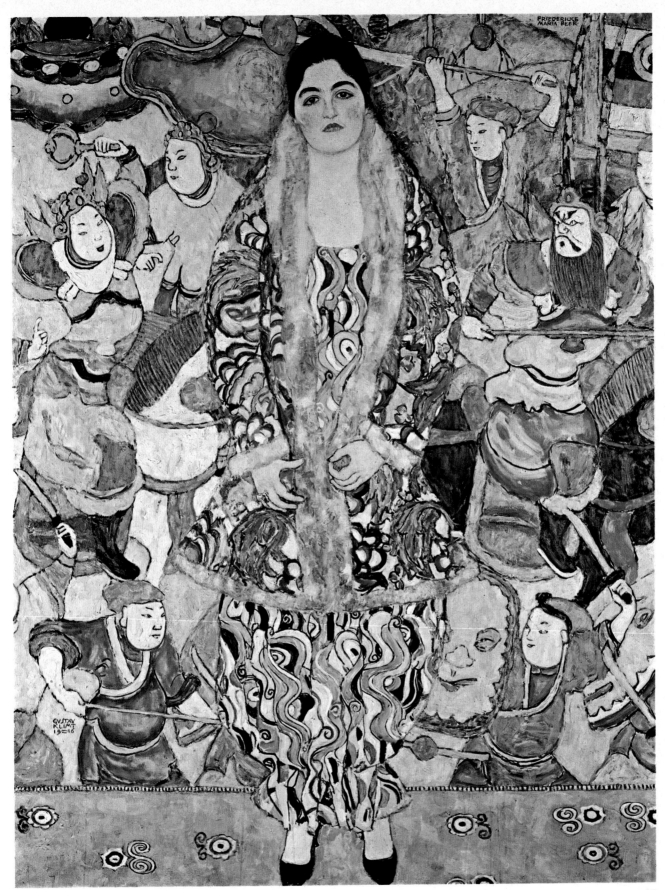

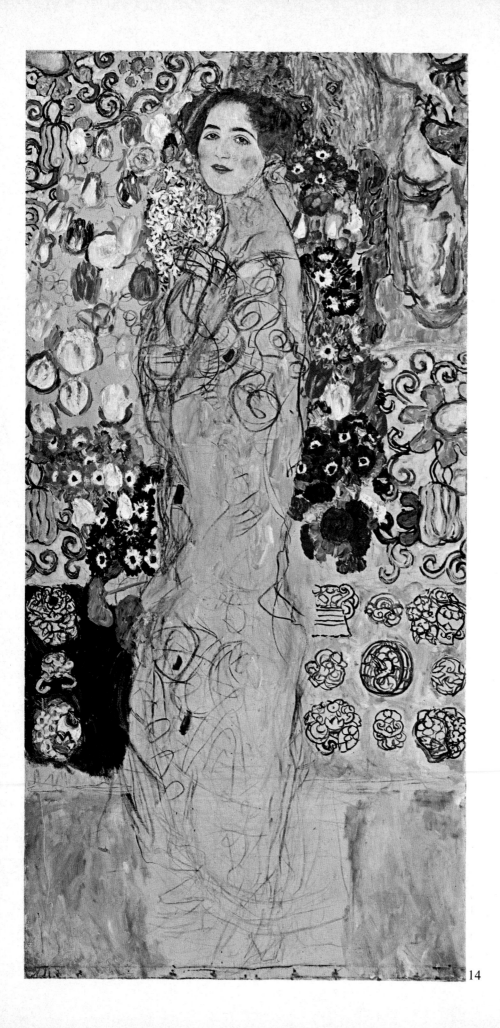

14

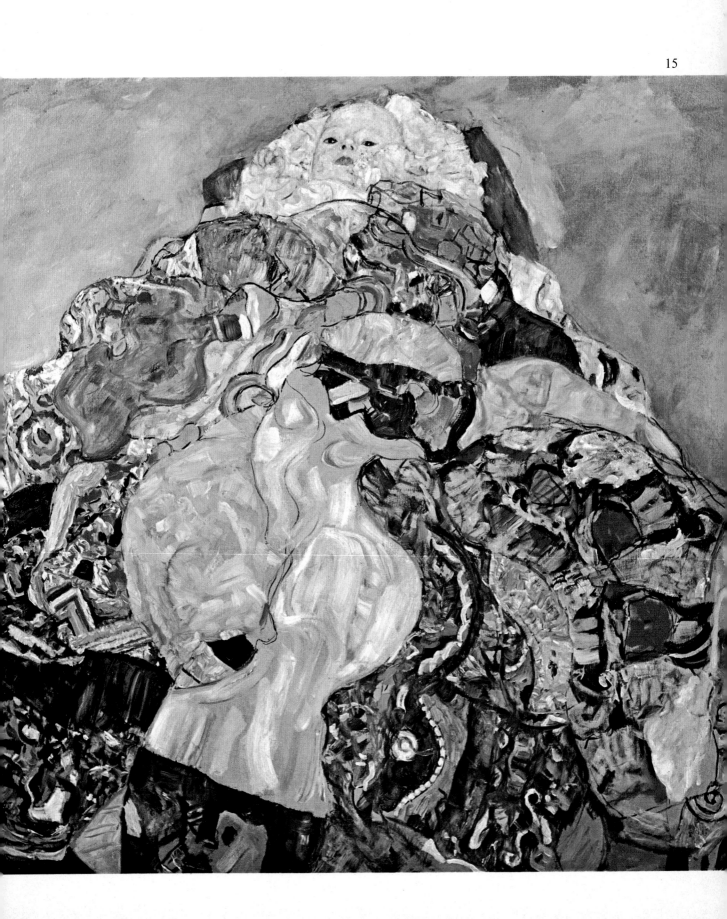

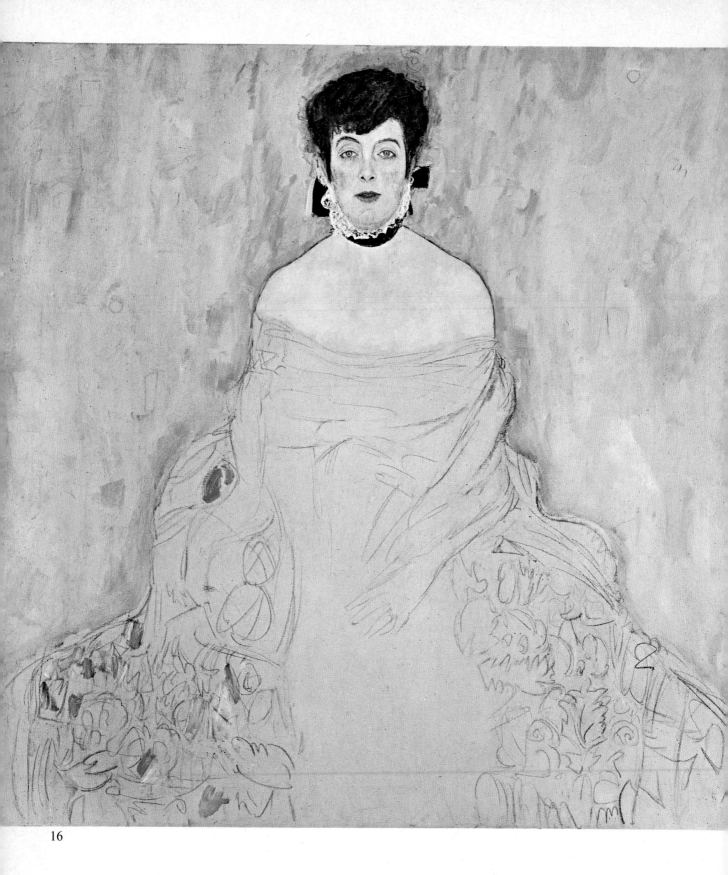

16

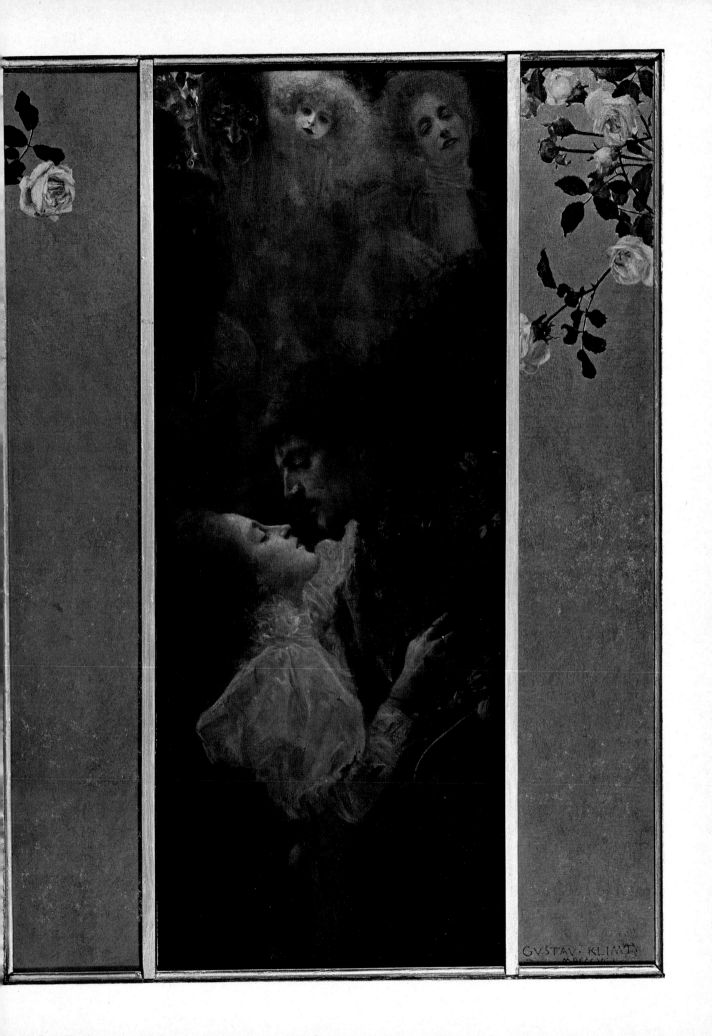

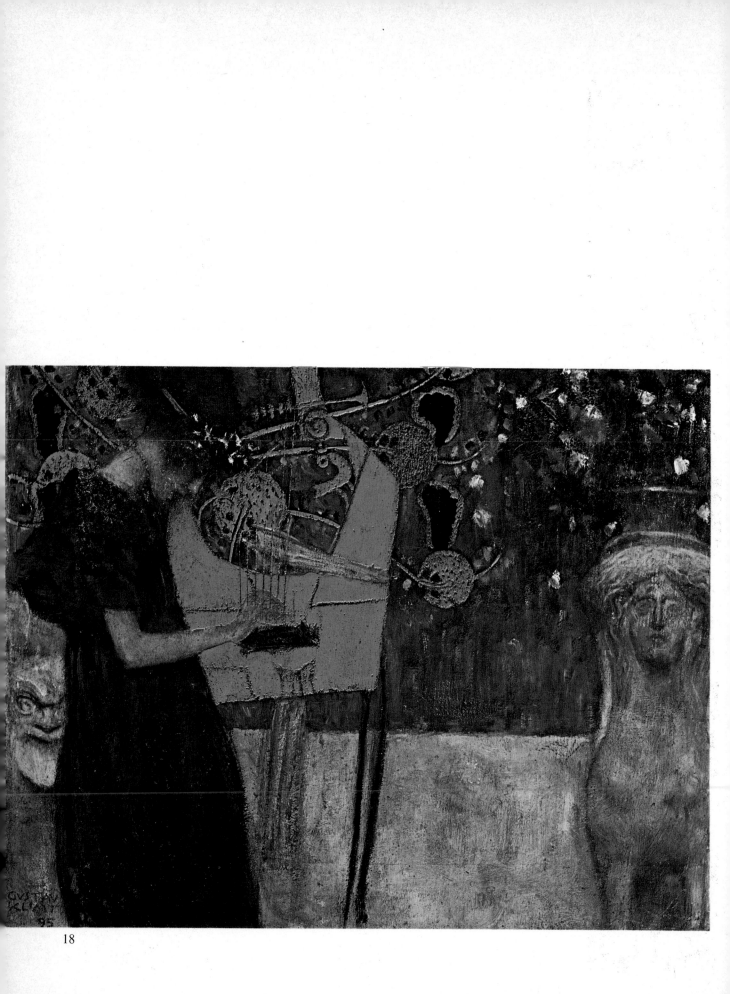

18

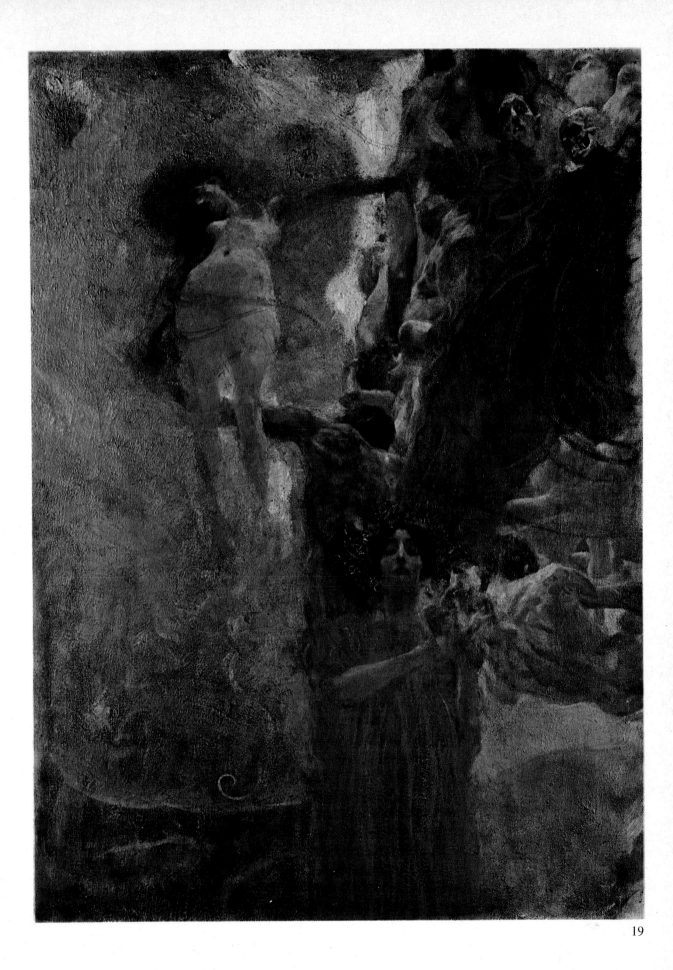

19

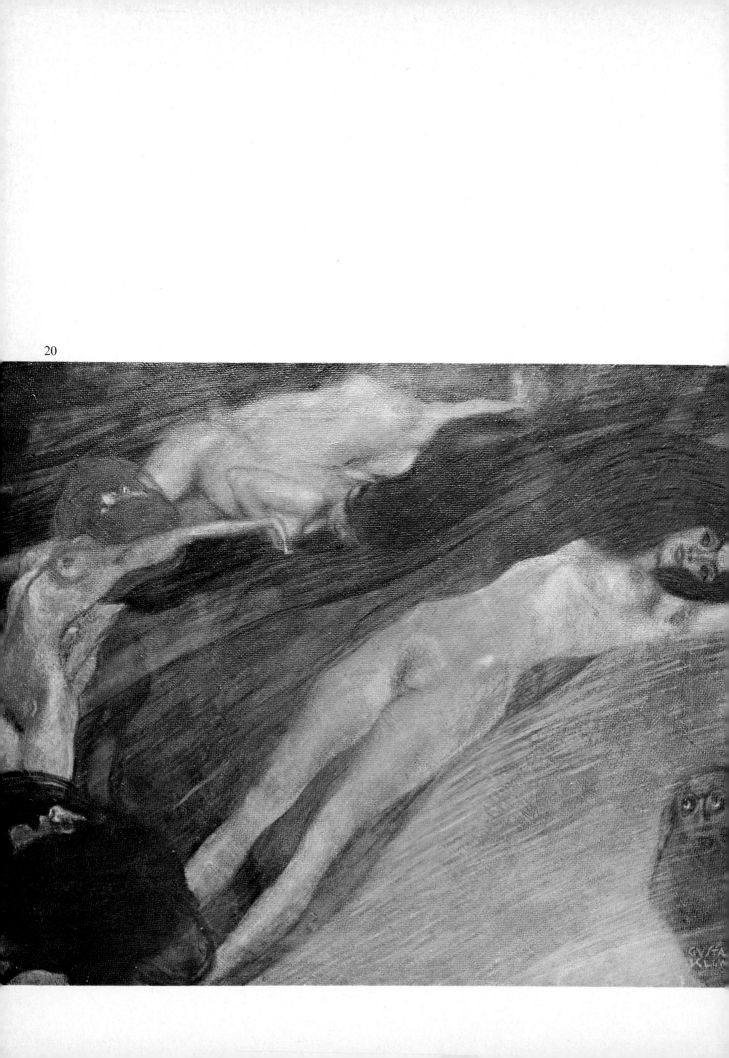

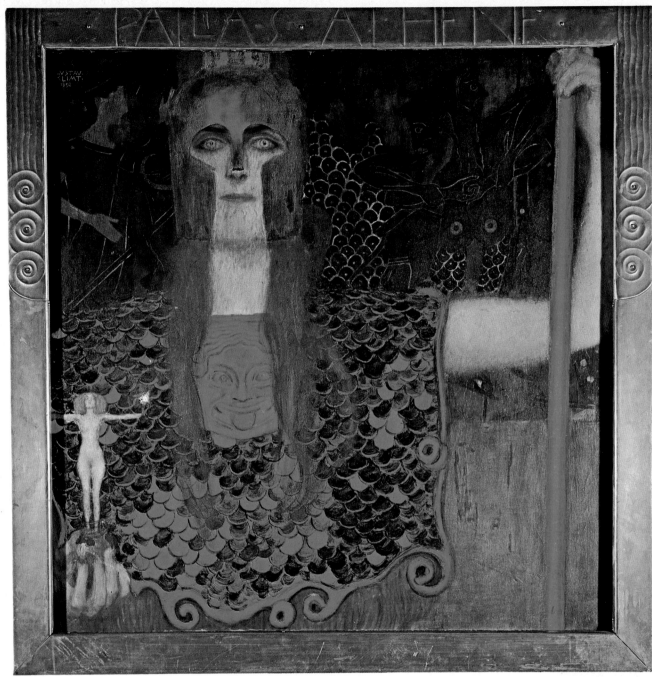

21

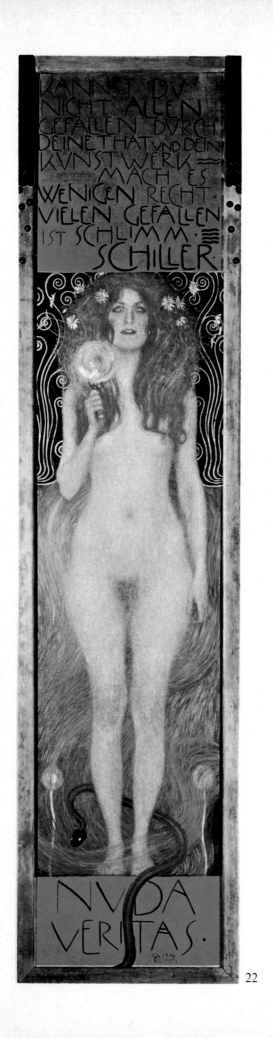

22

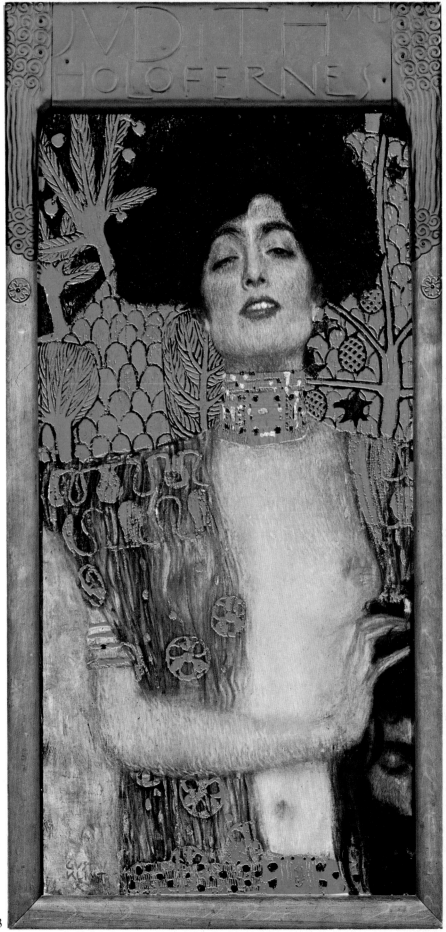

23

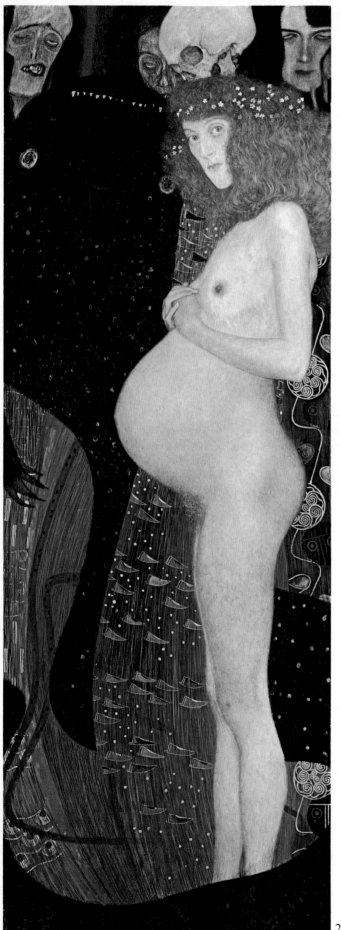

24

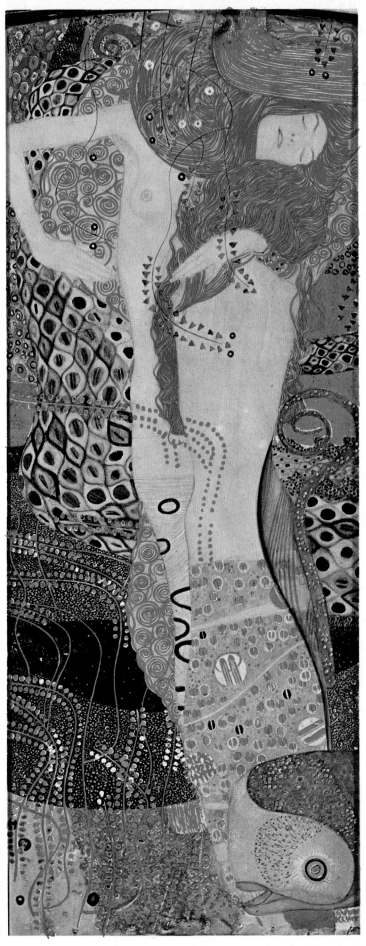

25

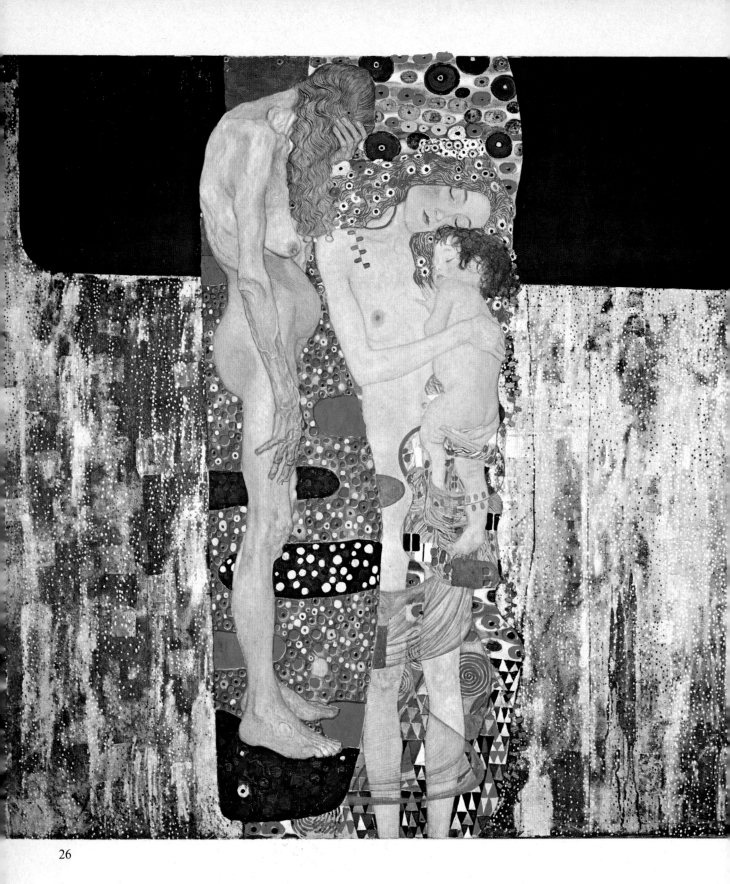

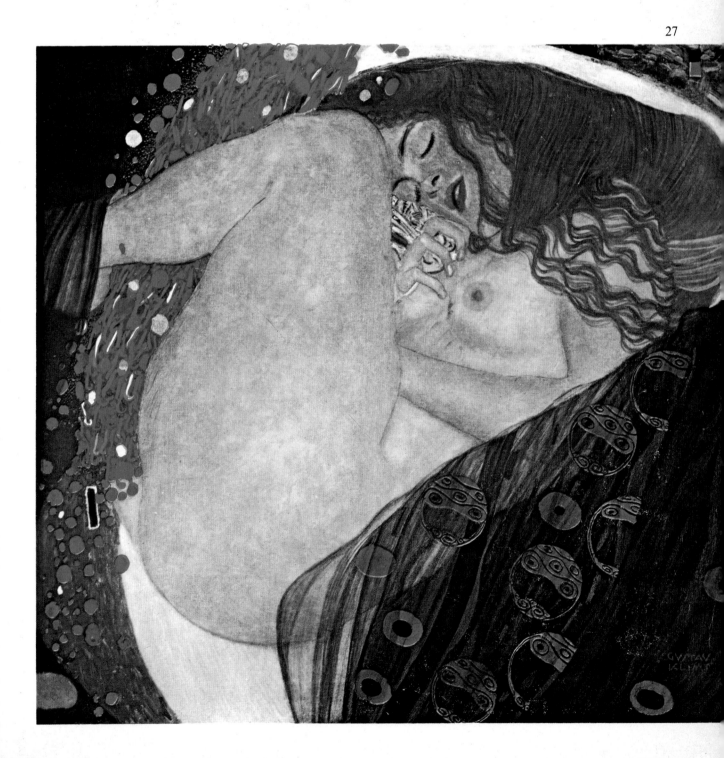

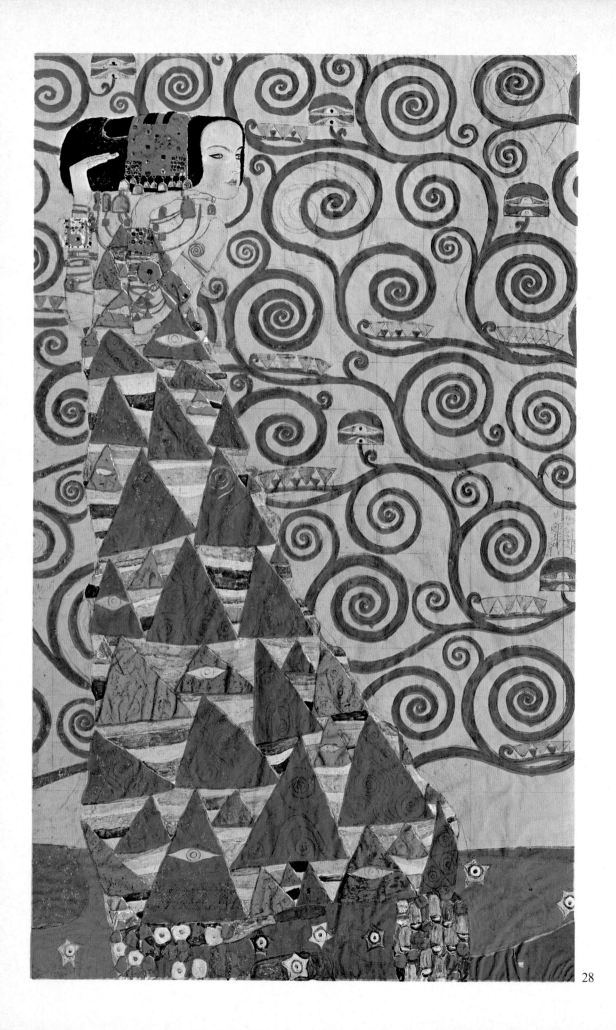

28

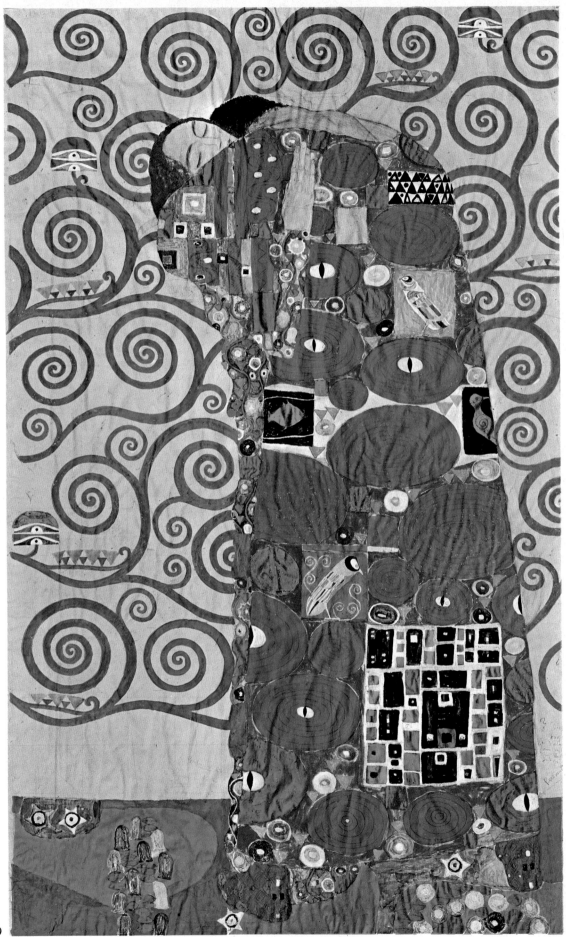

29

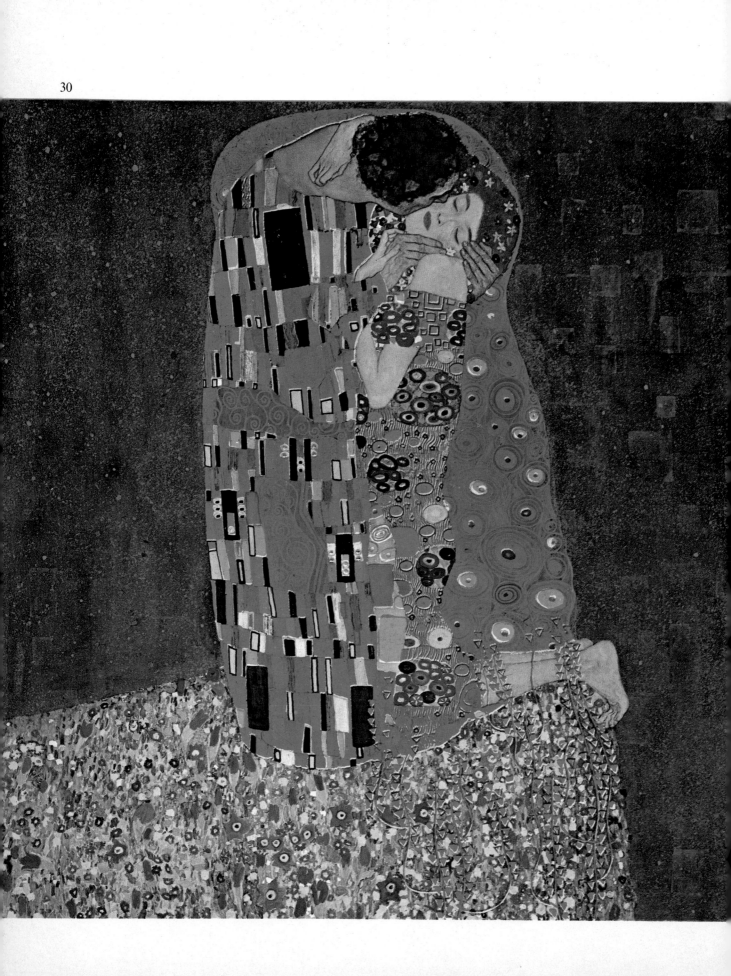

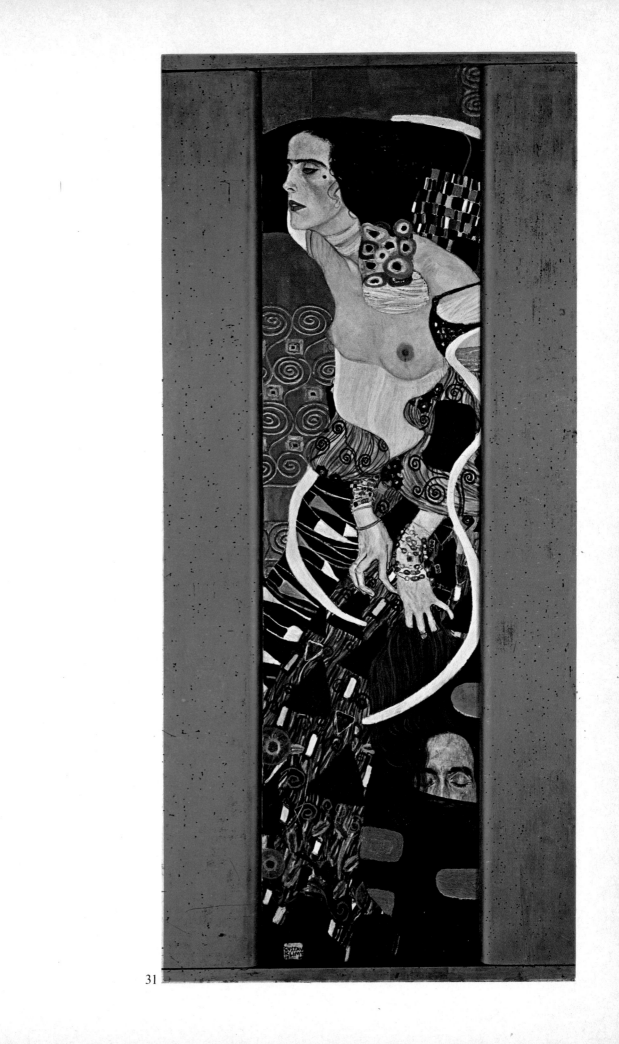

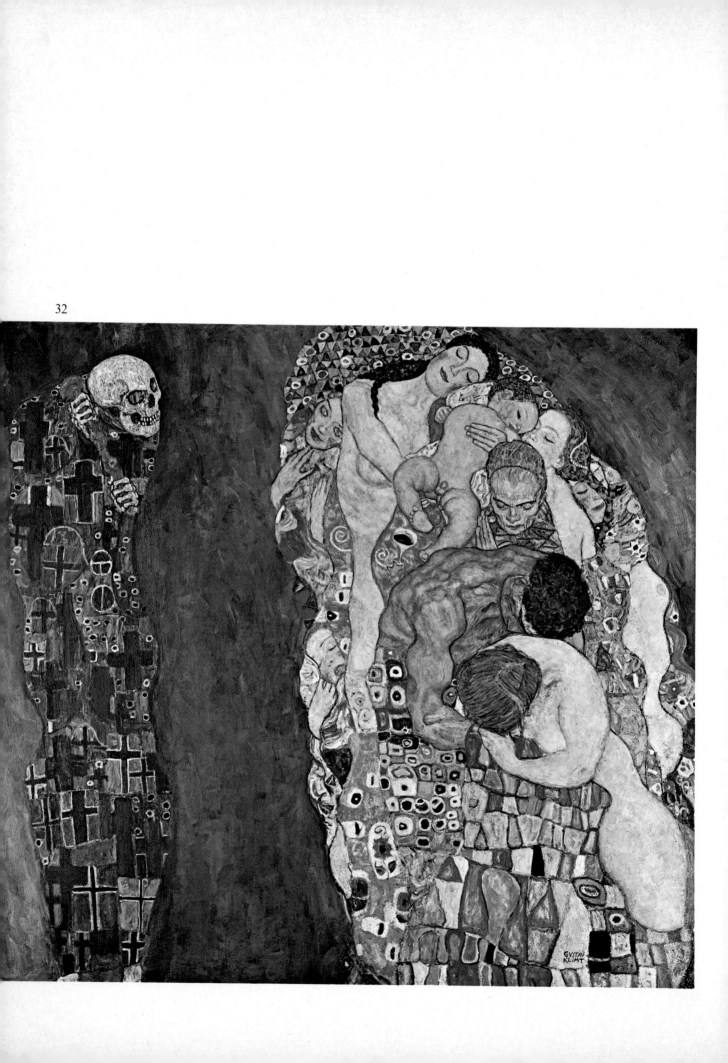

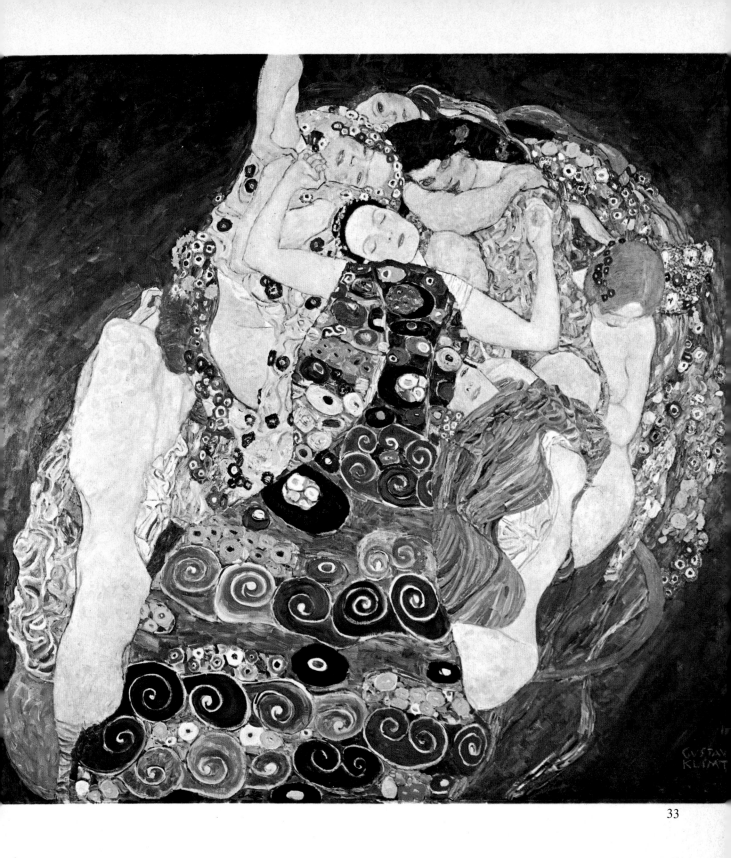

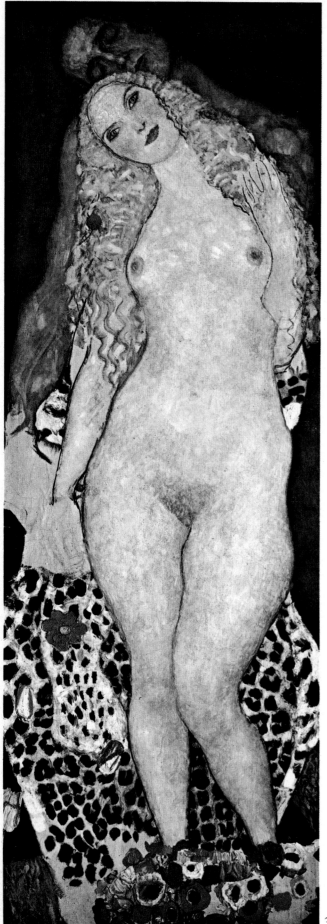

34

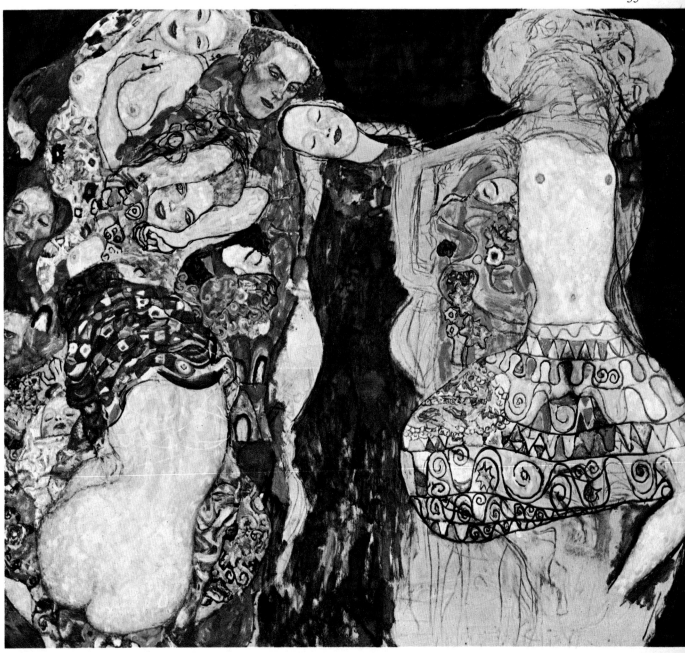

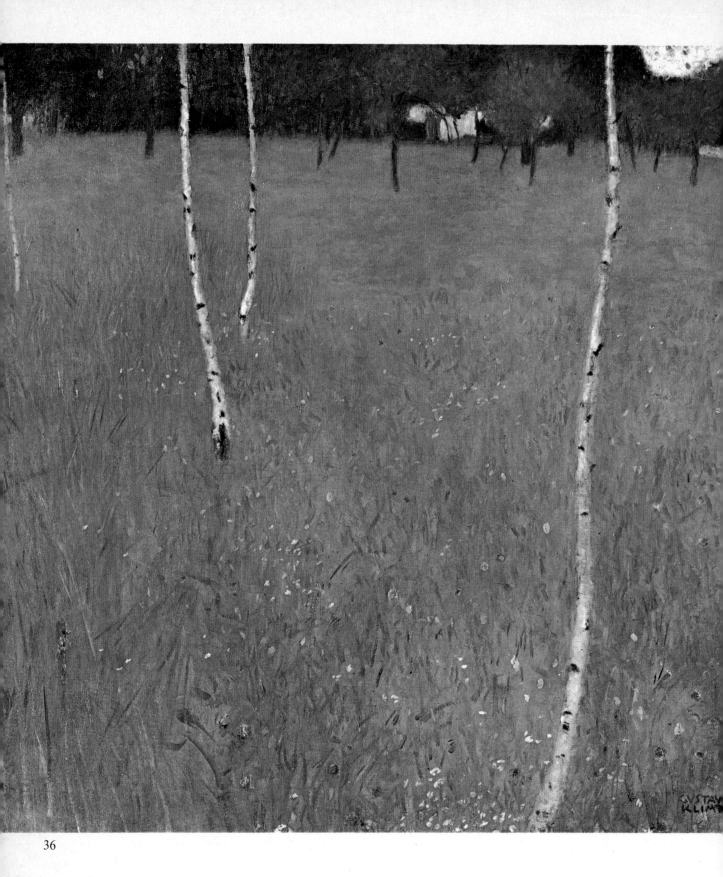

36

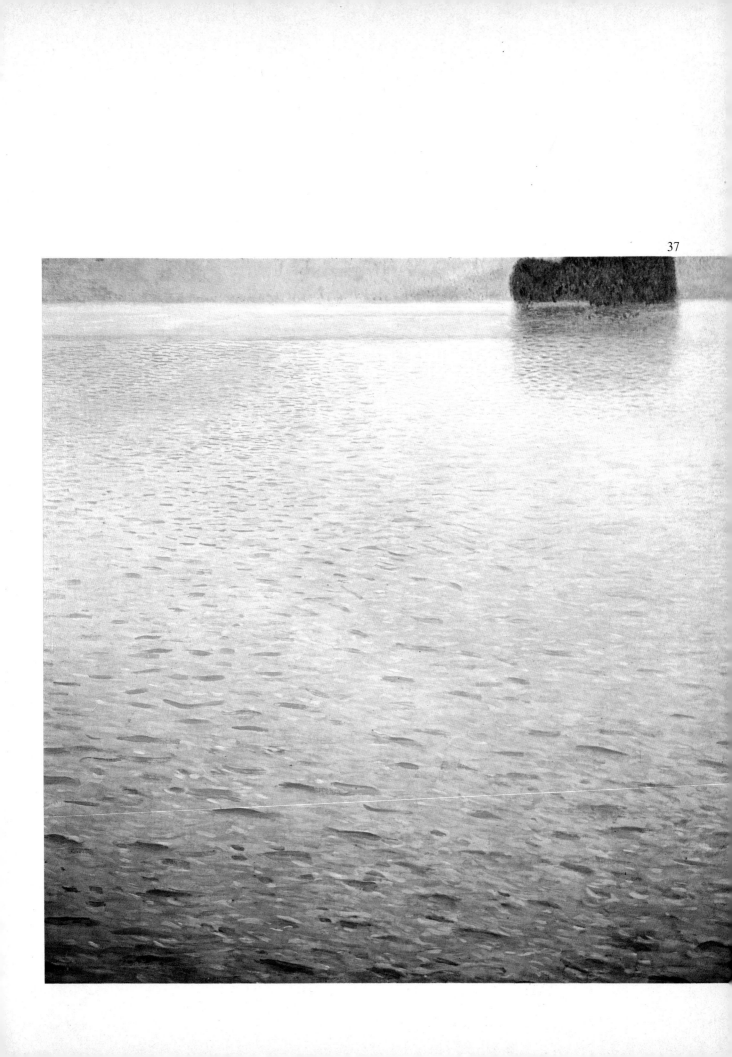

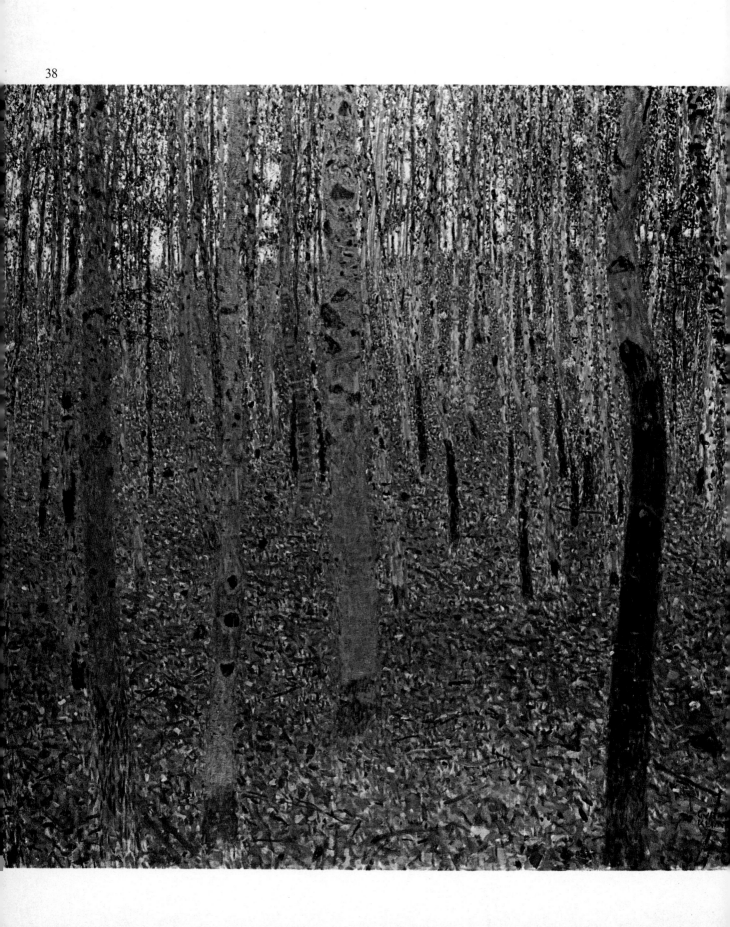

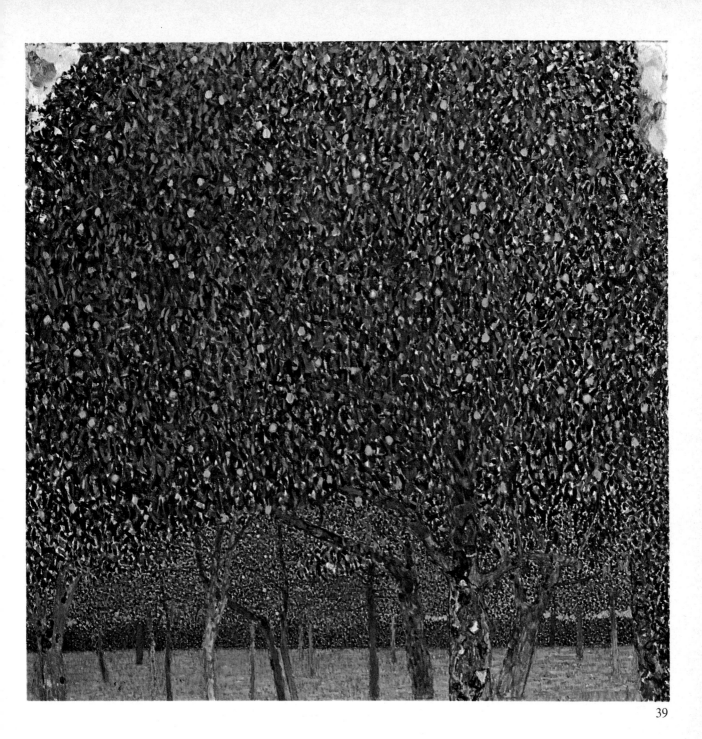

39

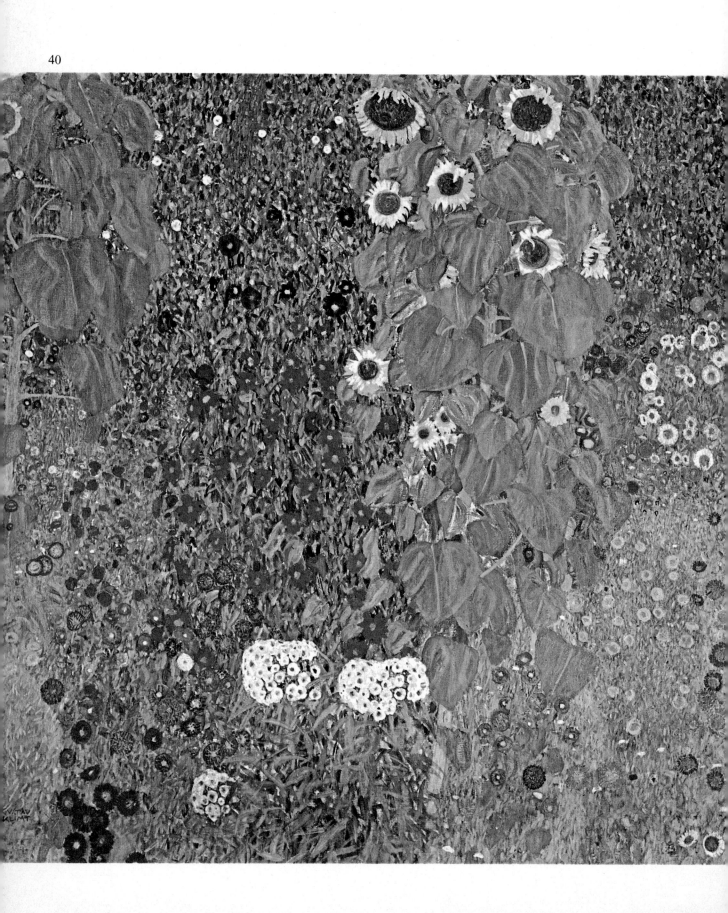

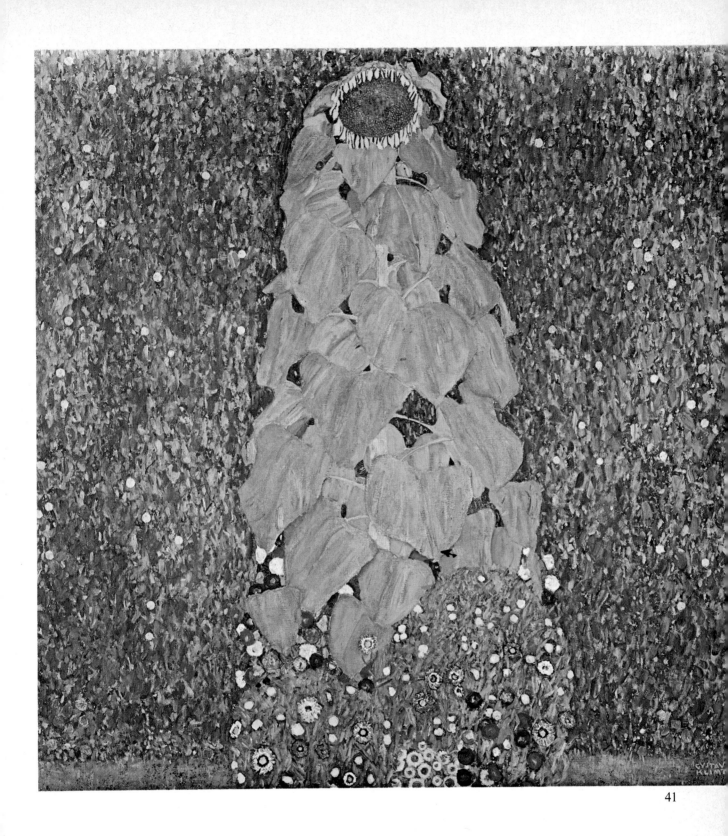

41

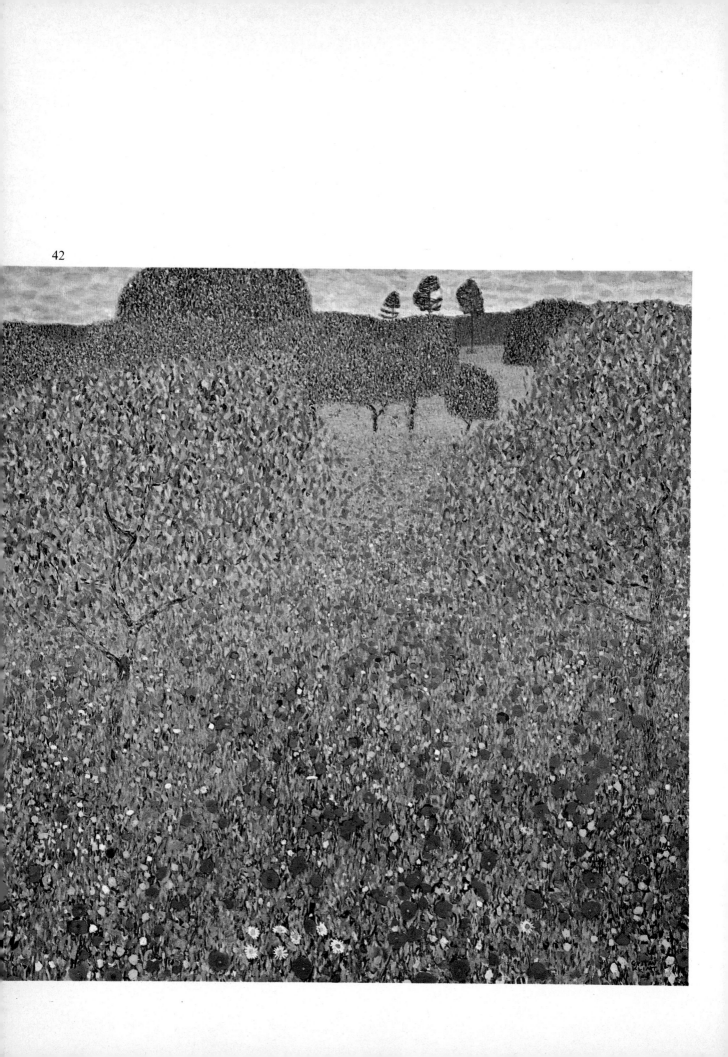

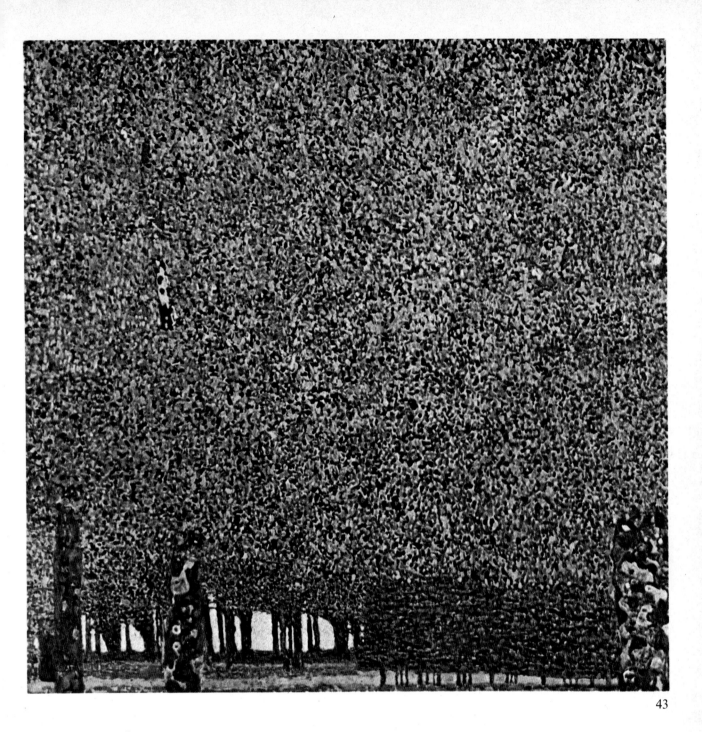

43

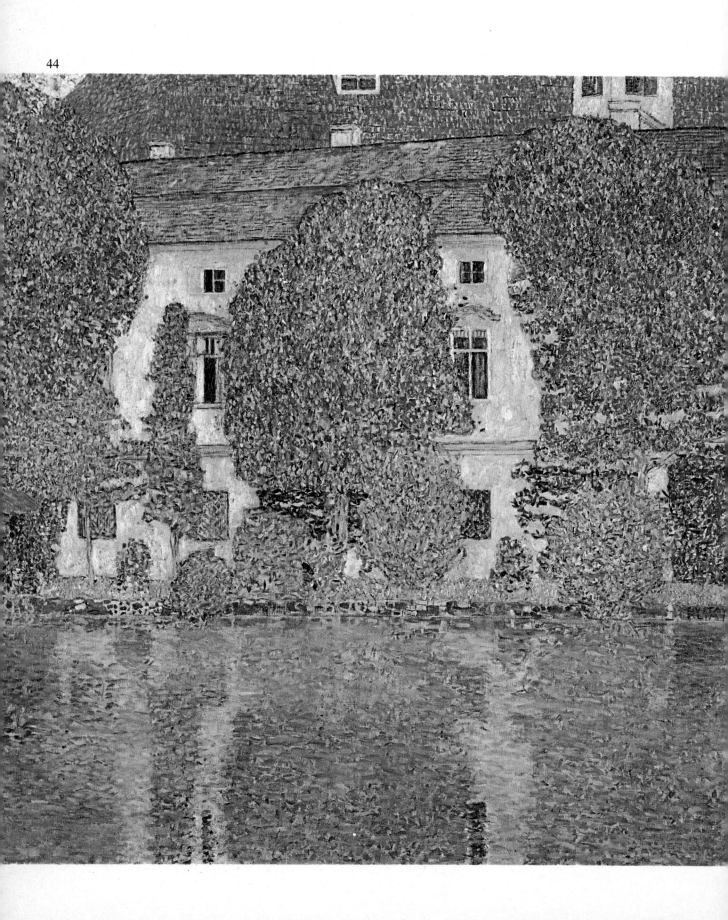

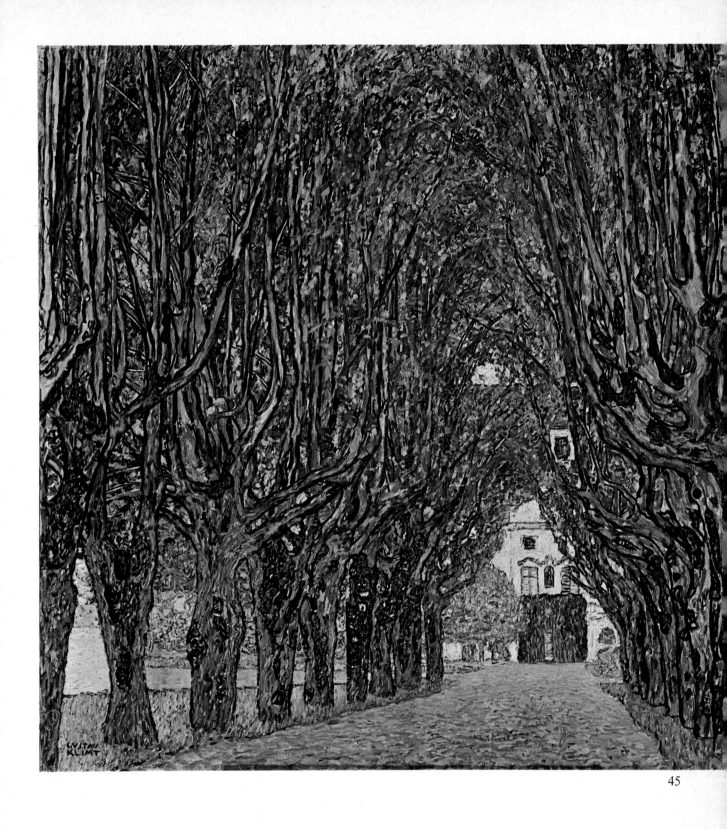

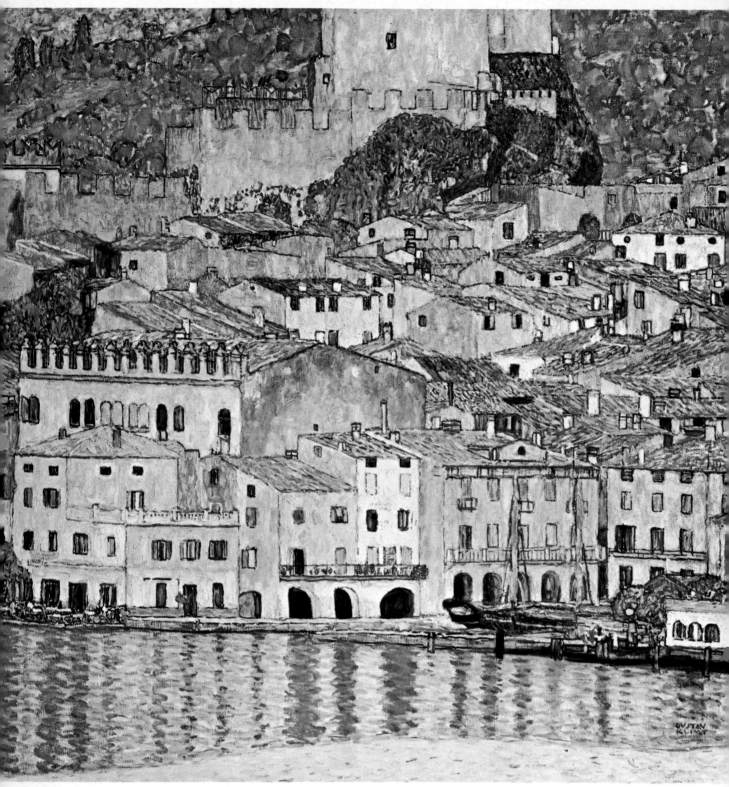

46

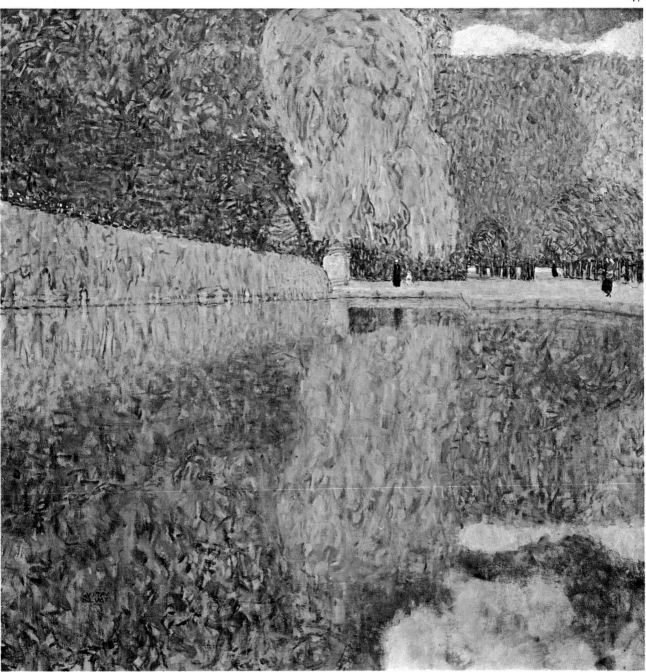

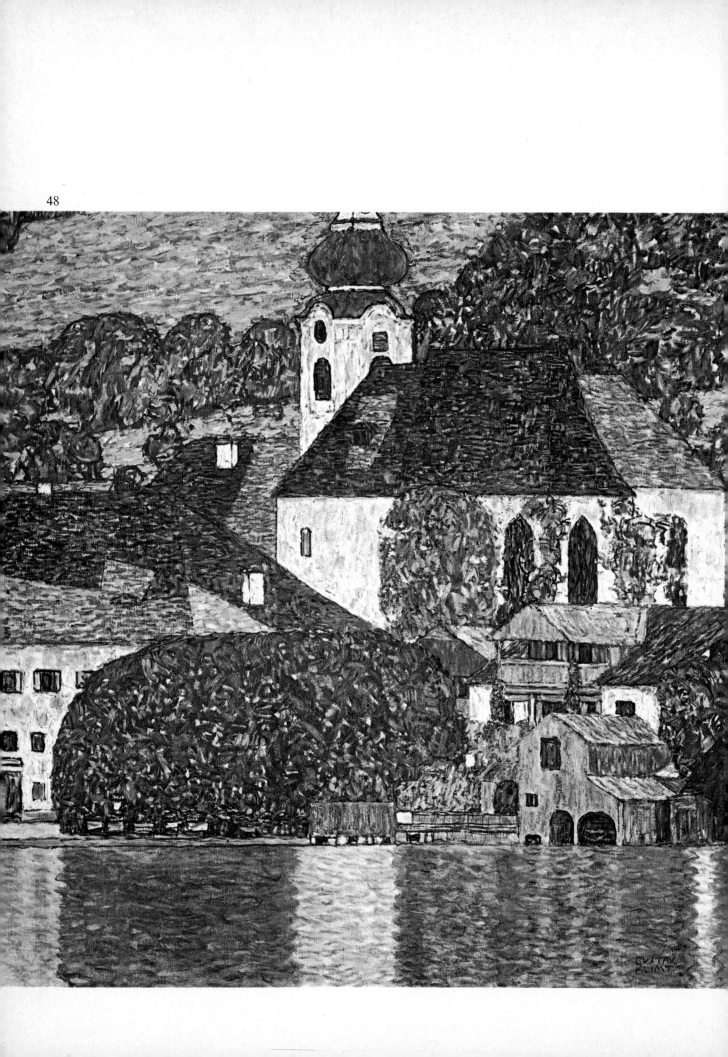

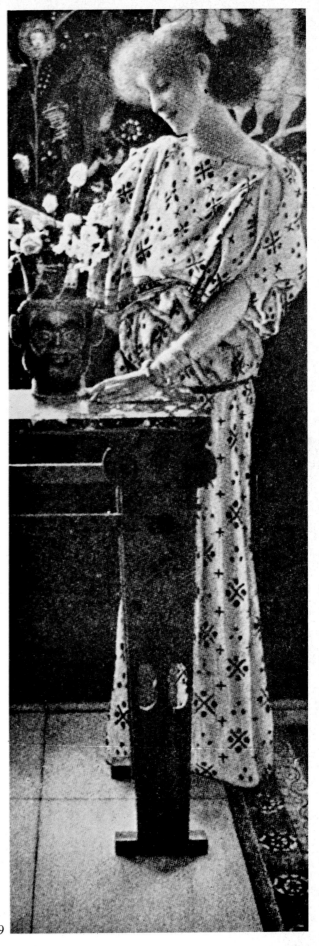

49

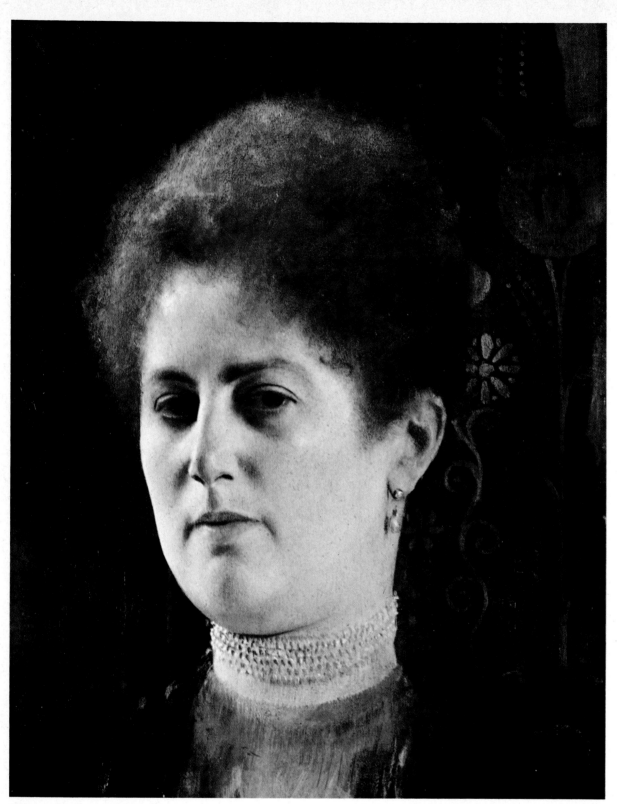

50

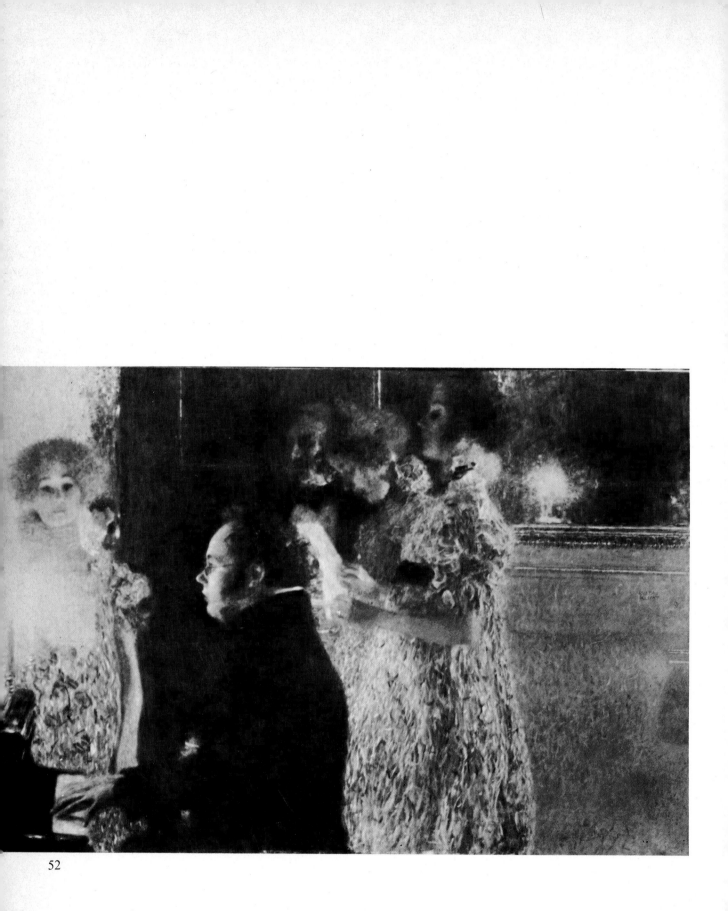

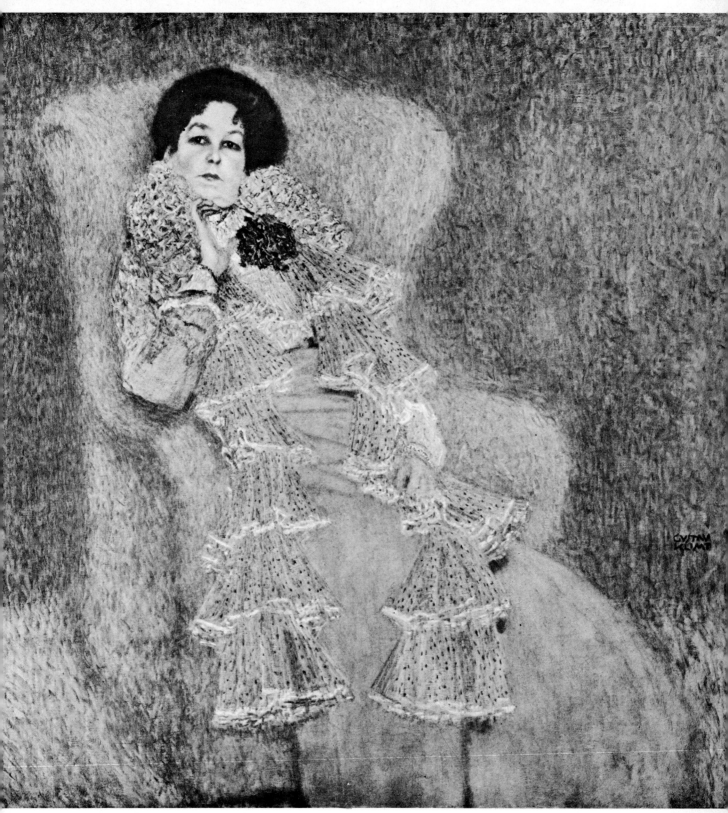

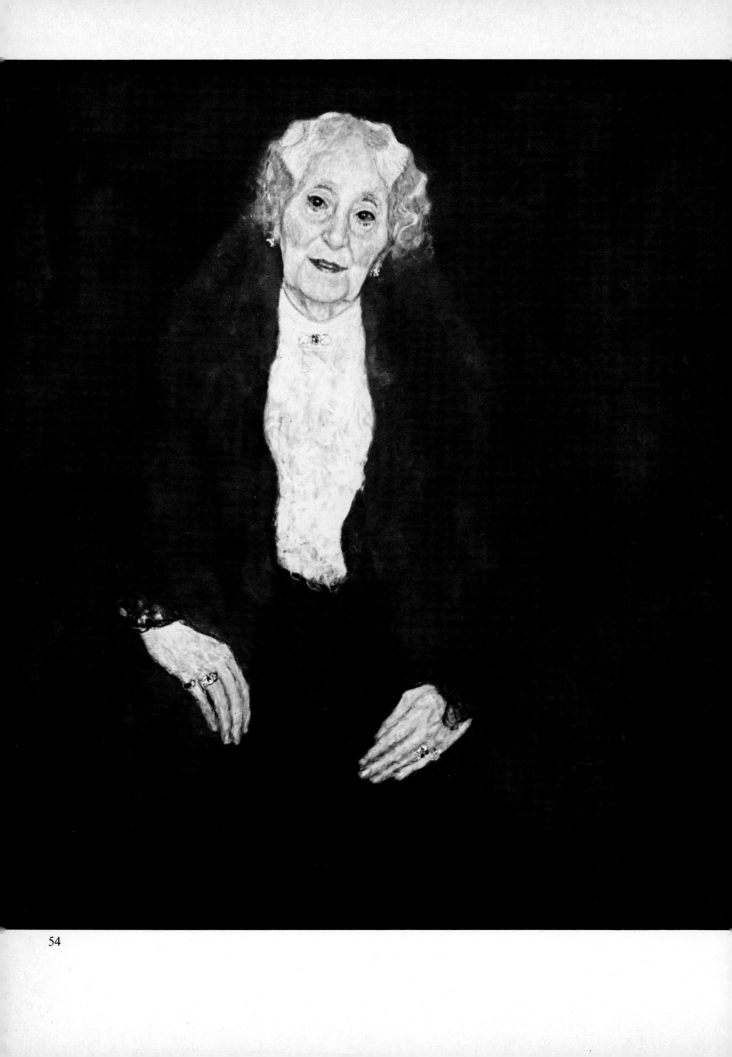

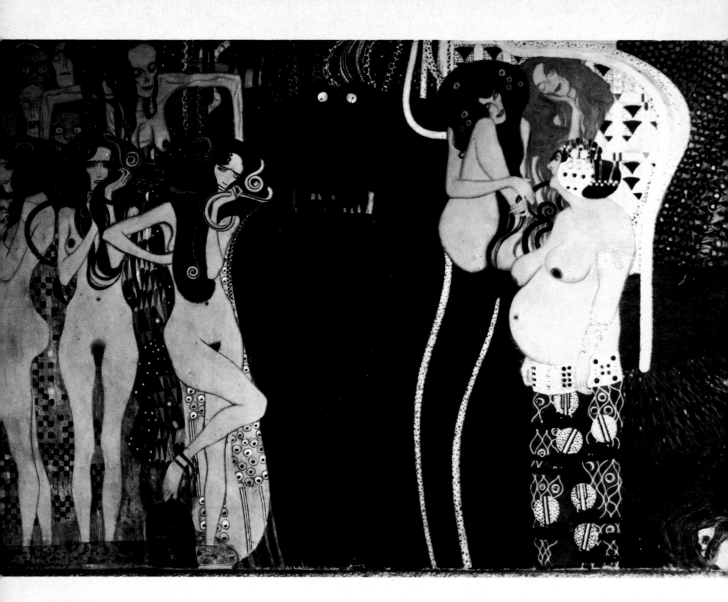

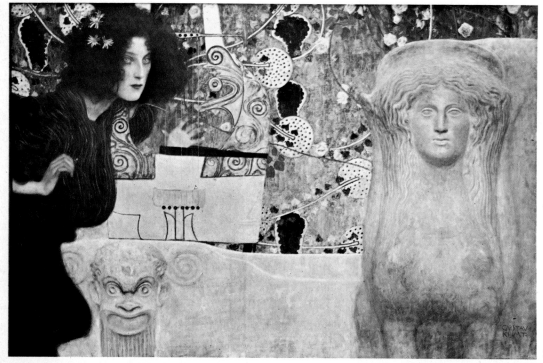

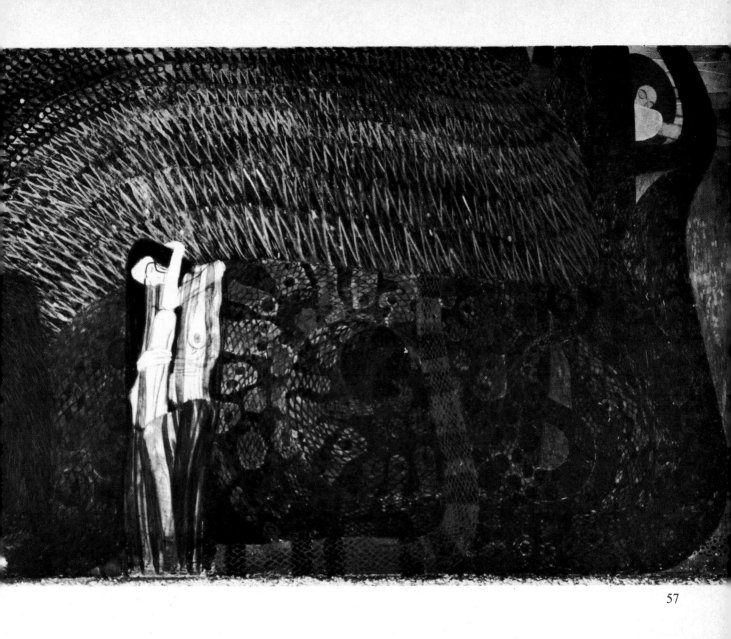

57

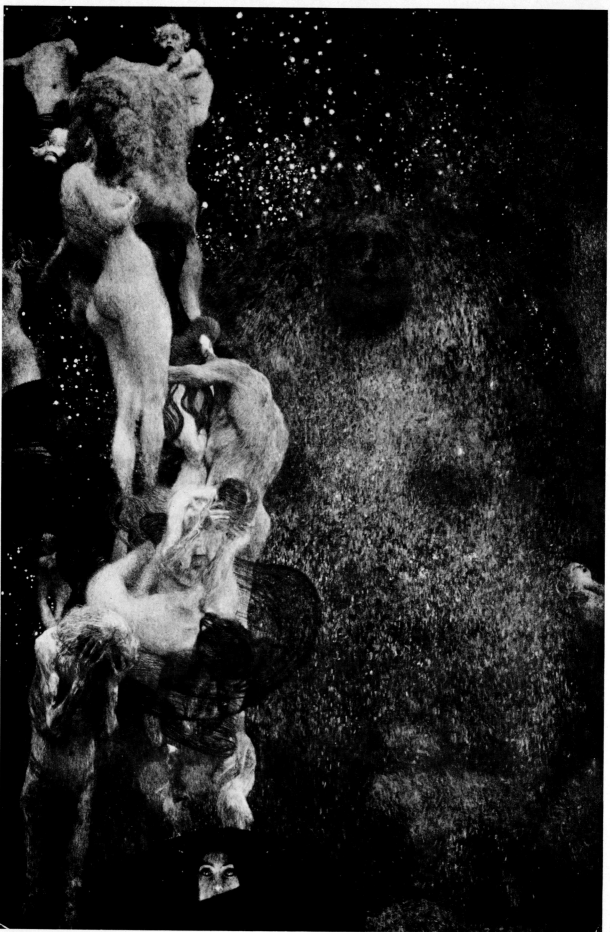

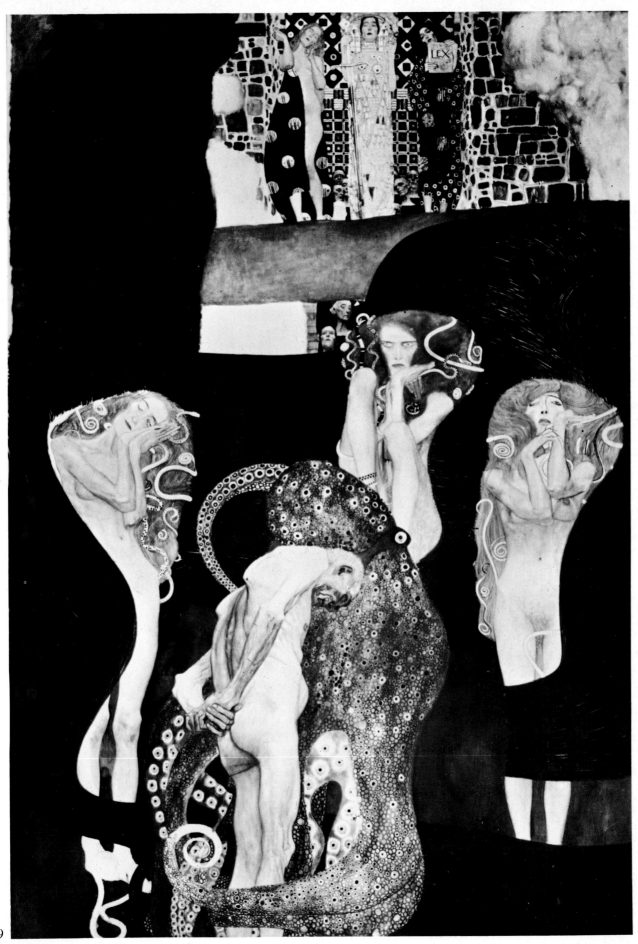

59

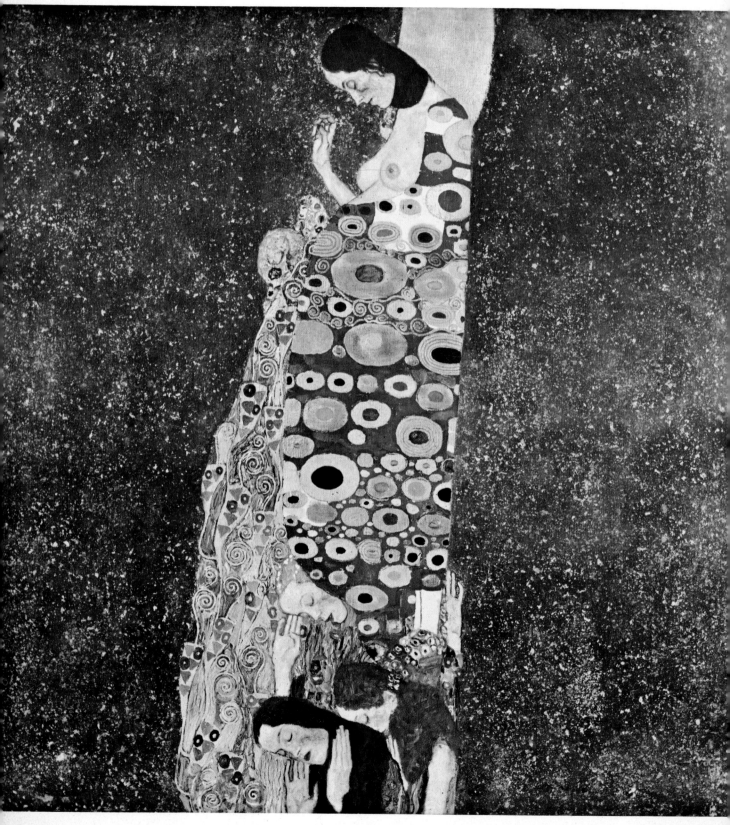

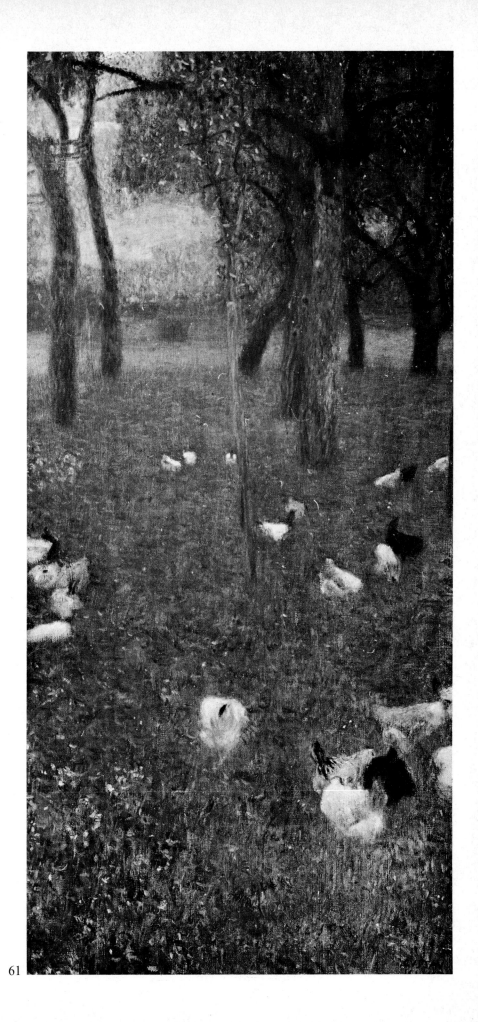

61

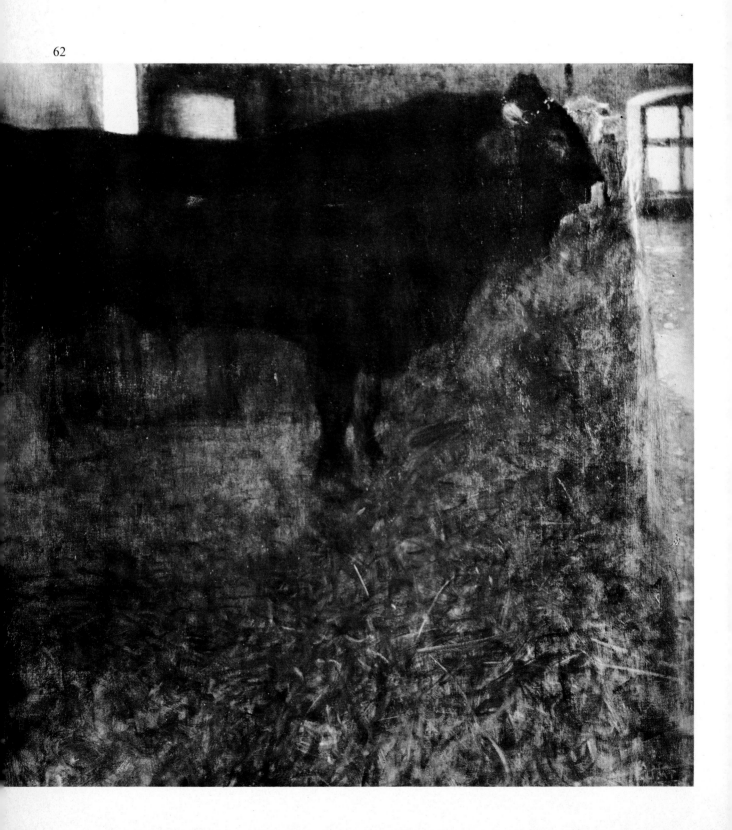

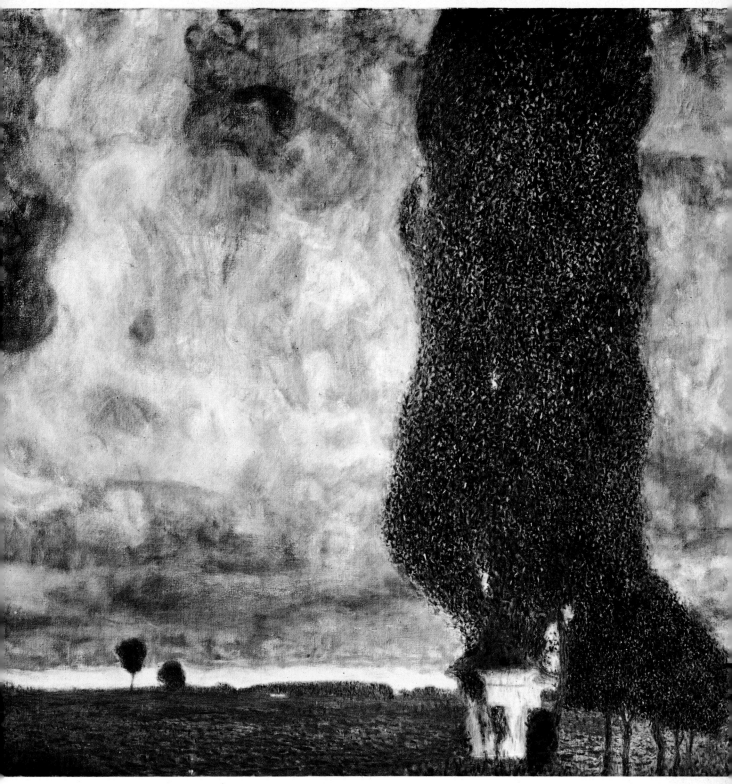

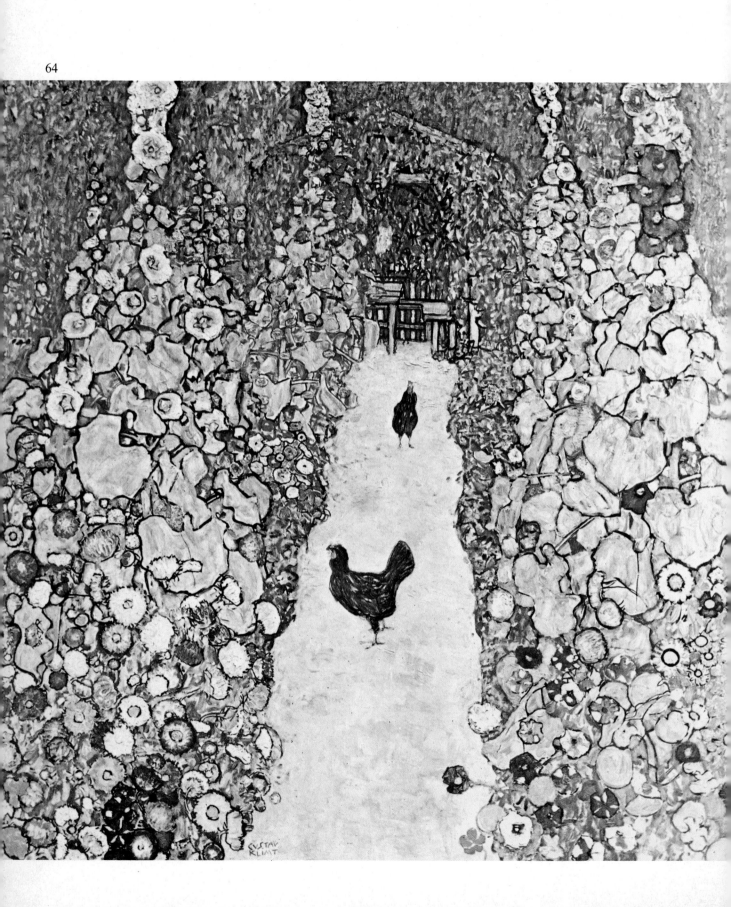

65

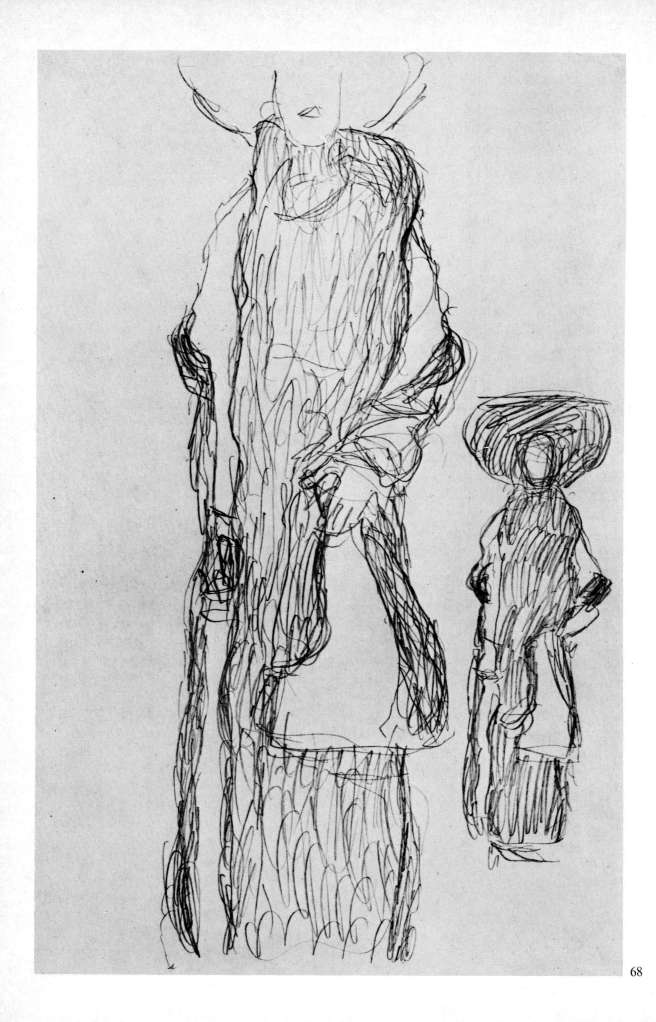

68

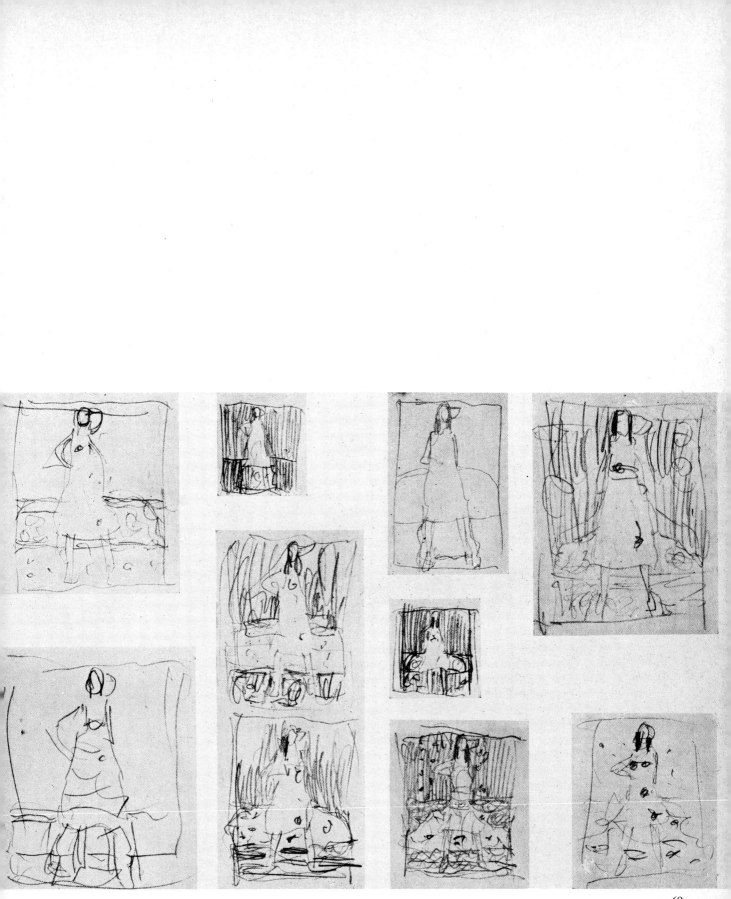

69

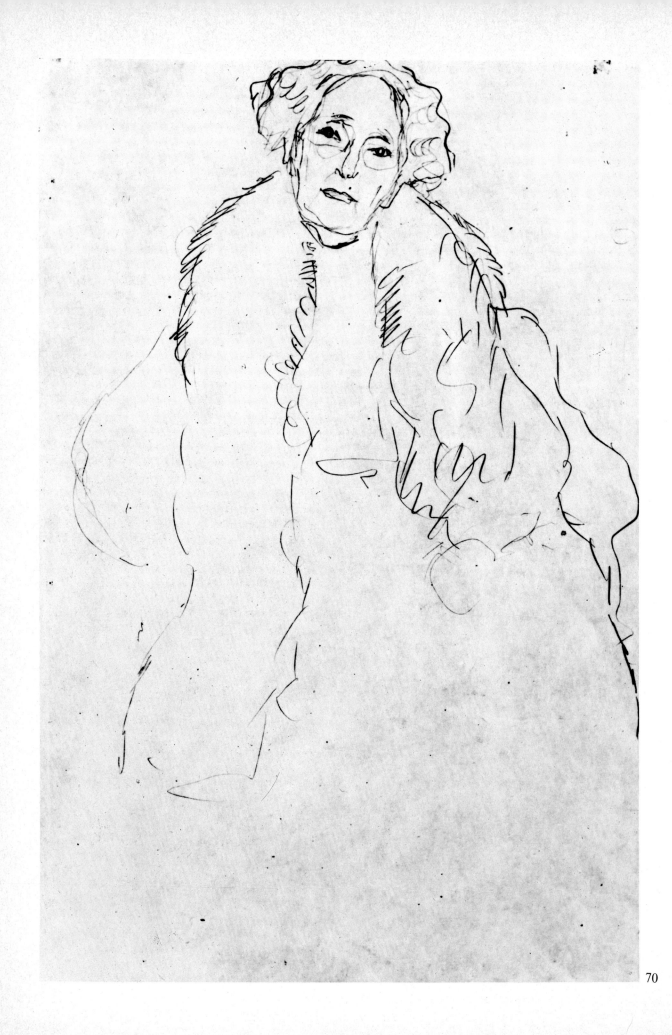

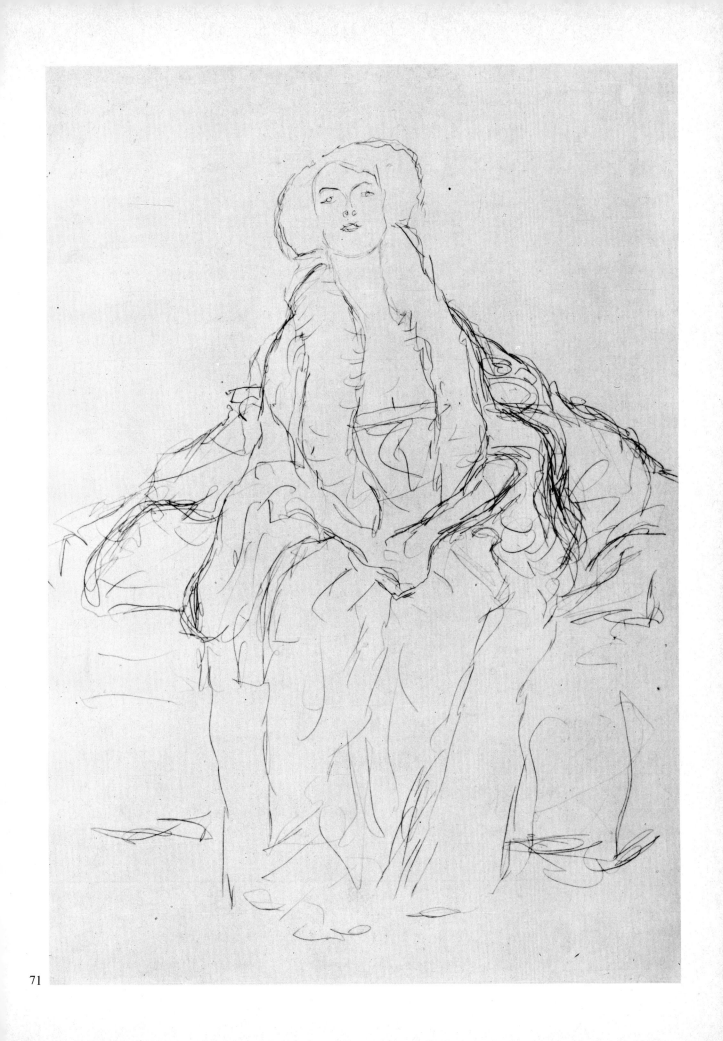

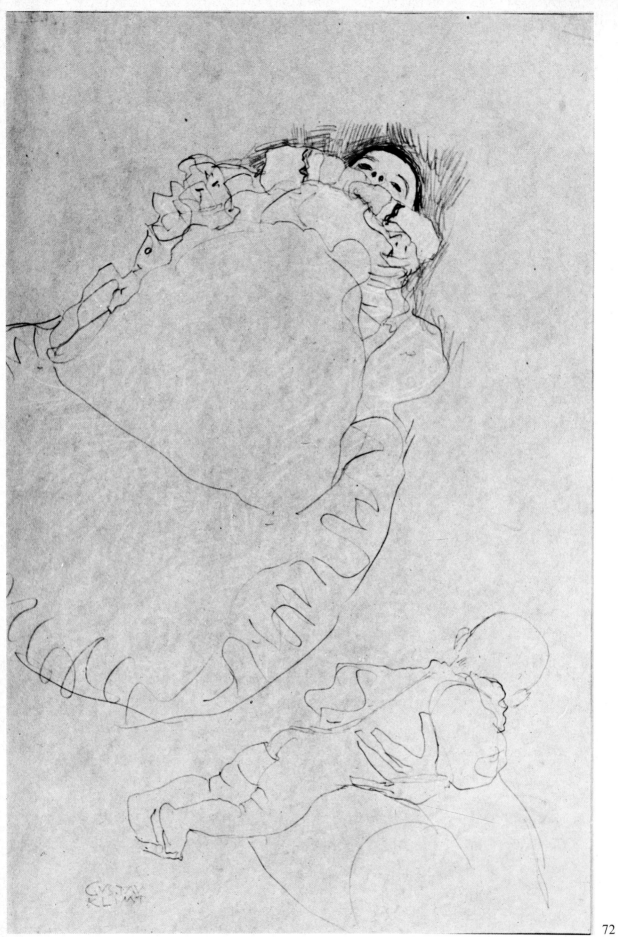

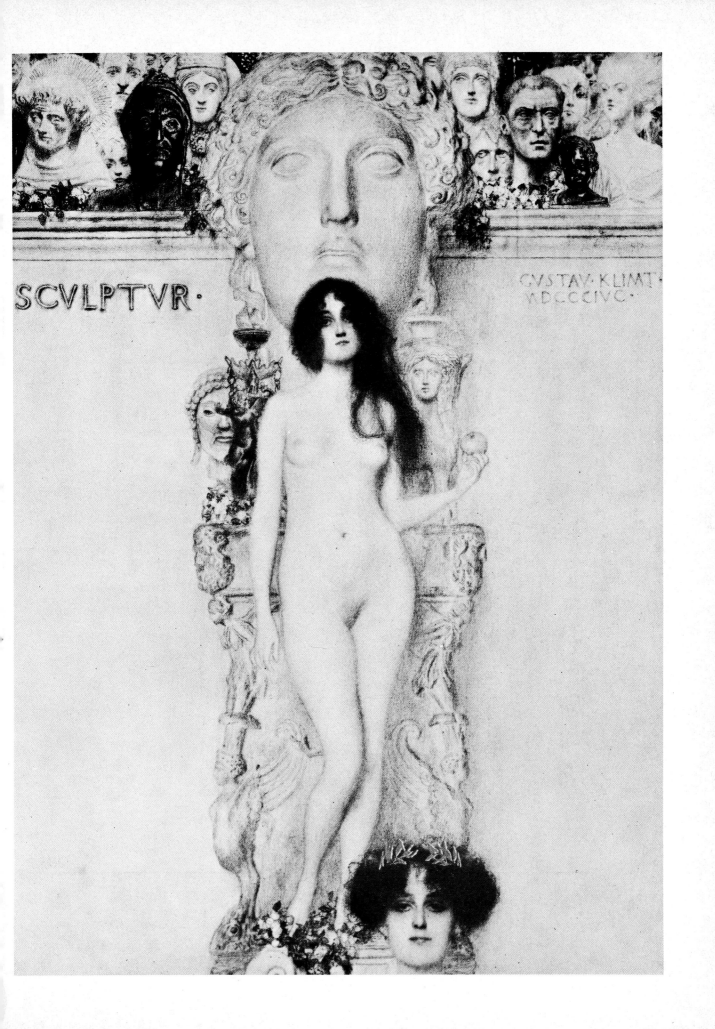

SCVLPTVR·

GVSTAV·KLIMT·
MDCCCIVC·

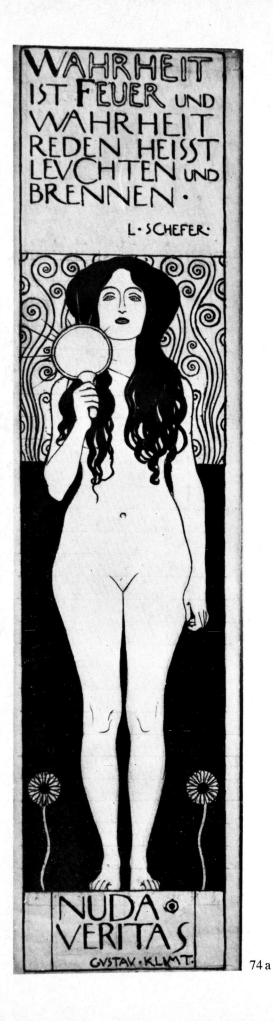

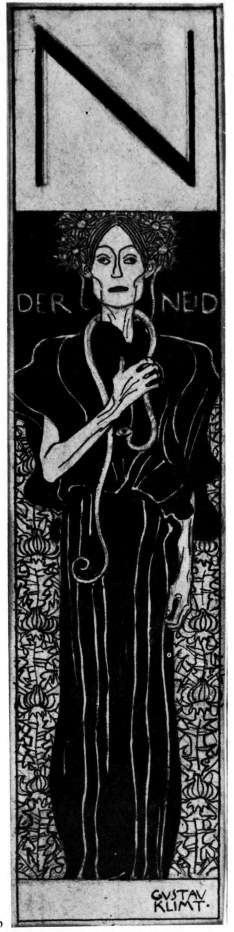

74a          74b

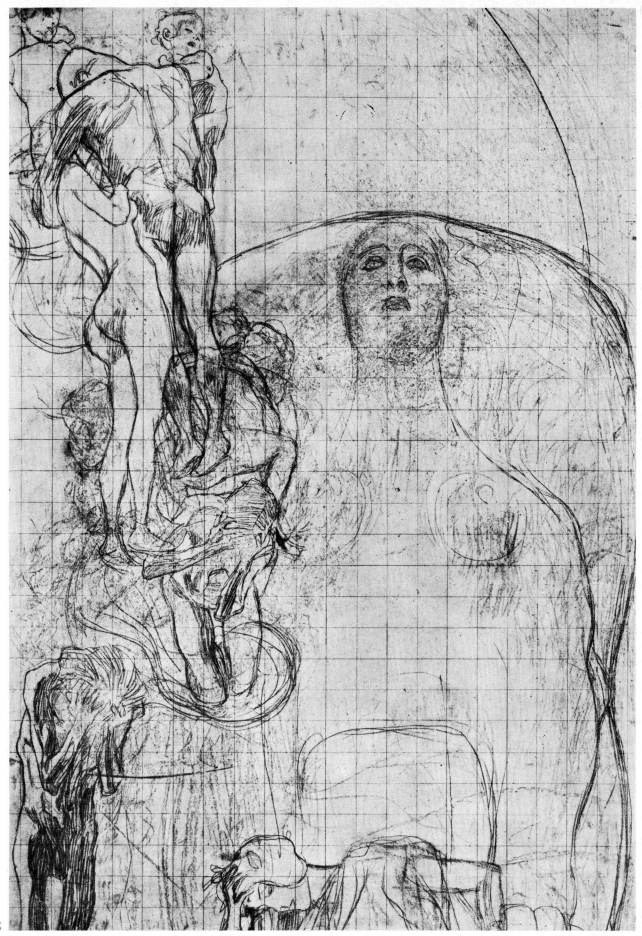

75

76 a

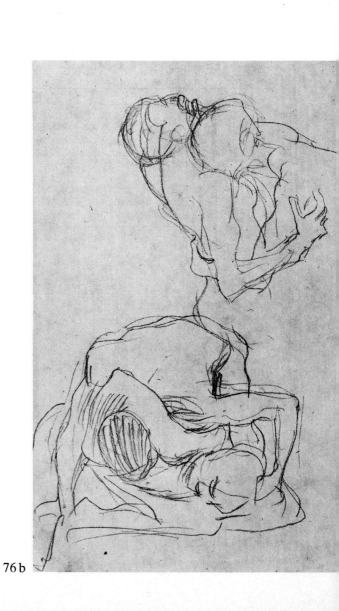

76 b

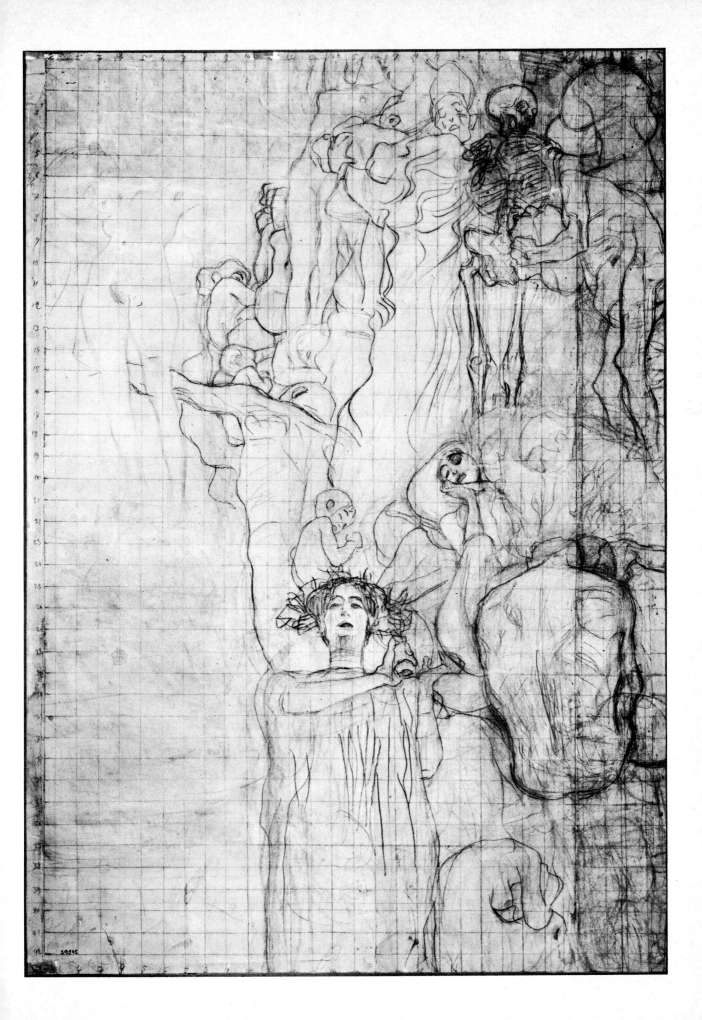

79